NICOLAS LANCRET

Dance Before a Fountain

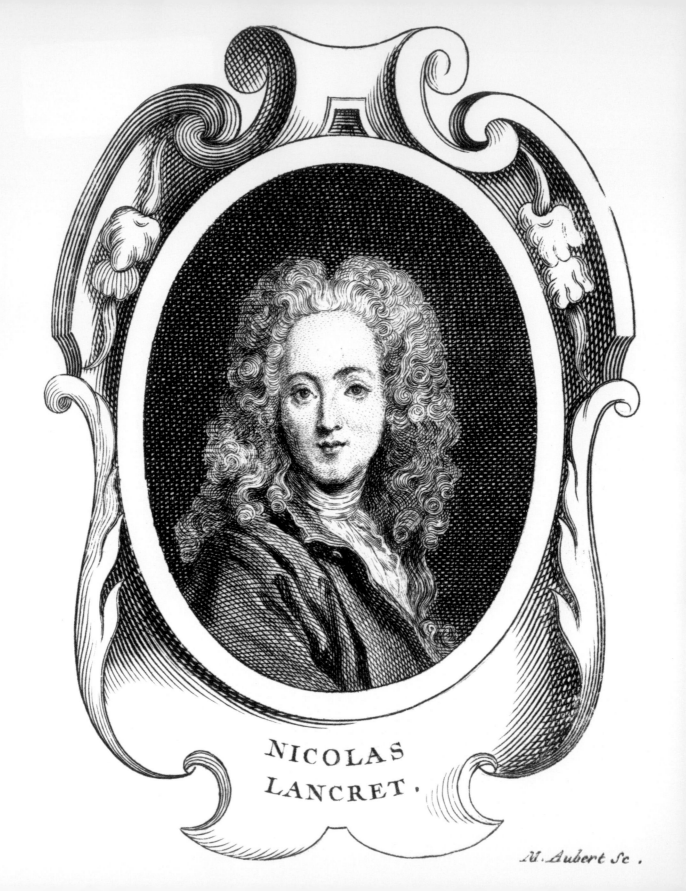

NICOLAS
LANCRET.

M. Aubert Sc.

NICOLAS LANCRET

Dance Before a Fountain

MARY TAVENER HOLMES
WITH A CONSERVATION NOTE BY MARK LEONARD

THE J. PAUL GETTY MUSEUM
LOS ANGELES

This book is dedicated to Donald Posner

GETTY MUSEUM STUDIES ON ART

© 2006 J. Paul Getty Trust

Getty Publications
1200 Getty Center Drive, Suite 500
Los Angeles, California 90049-1682
www.getty.edu

Christopher Hudson, *Publisher*
Mark Greenberg, *Editor in Chief*

Mollie Holtman, *Series Editor*
Abby Sider, *Manuscript Editor*
Catherine Lorenz, *Designer*
Suzanne Watson, *Production Coordinator*
Lou Meluso, Anthony Peres, Jack Ross, *Photographers*

Typesetting by Diane Franco
Printed in China by Imago

Library of Congress Cataloging-in-Publication Data

Holmes, Mary Tavener.
 Nicolas Lancret : Dance before a fountain / Mary Tavener Holmes ;
with a conservation note by Mark Leonard.
 p. cm. — (Getty Museum studies on art)
 Includes bibliographical references and index.
 ISBN-13: 978-0-89236-832-7 (pbk.)
 ISBN-10: 0-89236-832-2 (pbk.)
1. Lancret, Nicolas, 1690–1743. Dance before a fountain. 2. Lancret,
Nicolas, 1690–1743—Criticism and interpretation. 3. Genre painting,
French—18th century. I. Leonard, Mark, 1954– II. Lancret, Nicolas,
1690–1743. III. J. Paul Getty Museum. IV. Title. V. Series.
 ND553.L225A65 2006
 759.4—dc22
 2005012001

Frontispiece:
Michel Aubert (French, 1700–1757), *Nicolas Lancret* [detail], engraving,
from Antoine Joseph Dezallier d'Argenville (French, 1680–1765), *Abrégé
de la vie des plus fameux peintres....* (Paris, 1745–52), vol. 3, p. 289.

Cover:
Nicolas Lancret (French, 1690–1743), *Dance Before a Fountain* [detail],
circa 1723. Oil on canvas, 96 × 138 cm (37^{13}/$_{16}$ × 54^{5}/$_{16}$ in.). Los Angeles,
J. Paul Getty Museum, 2001.54.

CONTENTS

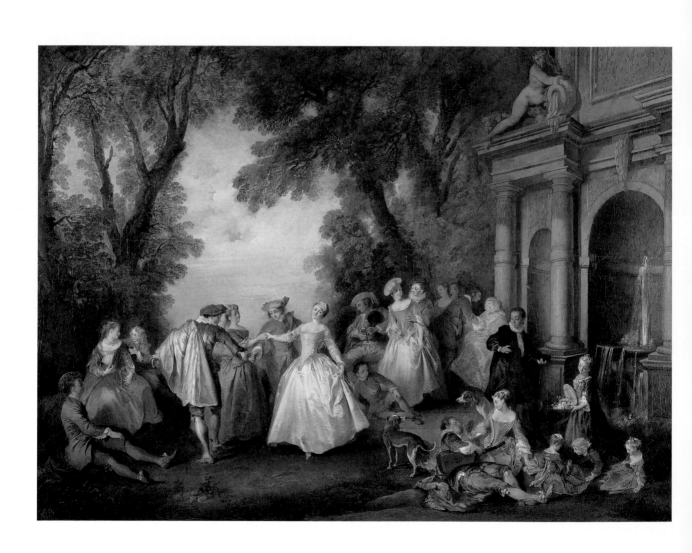

GREAT OLD MASTER PAINTINGS HAVE AN AIR OF FAMILIARITY ABOUT them, an air of inevitability, as if telling a story that we know and have always known, and telling it so well it seems the only way to tell it. The J. Paul Getty Museum has recently acquired such a work, Nicolas Lancret's *Dance Before a Fountain* [FIGURE 1]. The scene in this painting—the tenderness of hand meeting hand, the delicacy of glance and tilted head—describes the resolution of courtship confusion into a formal foursome, the dance bestowing a welcome clarity on the disorder of emotional life. The enticing familiarity of this masterpiece by Nicolas Lancret adds to the surprise when we realize that he is a very *unfamiliar* master, at least to American audiences. Works by Lancret, a revered painter in his own time and a favorite of crowned heads across eighteenth-century Europe, are a remarkably scarce commodity in museums in this country. There are modest examples of his work in several American museums, for example, in New York's Metropolitan Museum of Art [FIGURE 2] and the Cleveland Museum of Art.[1] The Boston Museum of Fine Arts has some small examples, and its Forsyth Wickes Collection boasts the magnificent and important, albeit small, autograph replica of Louis XV's *Luncheon Party in a Park* [FIGURE 3].[2] Washington, D.C., has the Getty picture's only rivals in scale, the National Gallery's two splendid examples, *Mademoiselle de Camargo Dancing* (see FIGURE 34) and *The Picnic After the Hunt* [FIGURE 4].[3]

The private sector adds a few more treasures; Lancret has always enjoyed a quiet success there. The late collector Chauncey Stillman's

I

FIGURE 1
Nicolas Lancret (French, 1690–1743), *Dance Before a Fountain*, circa 1723. Oil on canvas, 96 × 138 cm (37^{13}/₁₆ × 54⁵/₁₆ in.). Los Angeles, J. Paul Getty Museum, 2001.54.

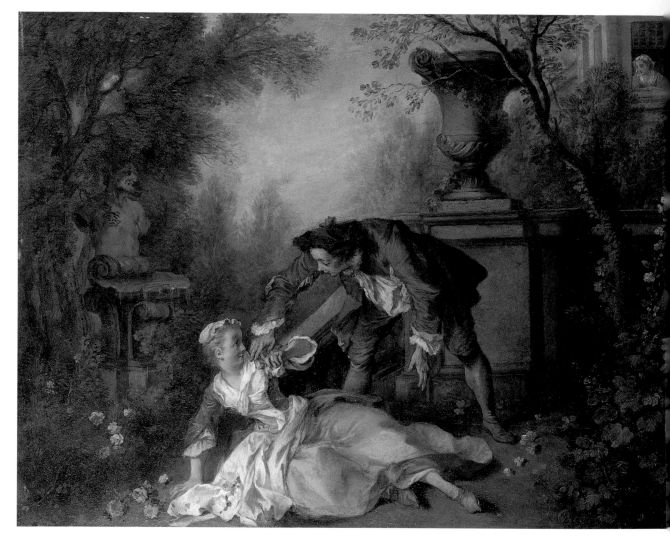

FIGURE 2
Nicolas Lancret, *The Servant
Justified*, 1736. Oil on copper,
27.9 × 35.6 cm (11 × 14 in.).
New York, Metropolitan Museum
of Art, Purchase, Walter H. and
Leonore Annenberg and The
Annenberg Foundation Gift,
2004.85.

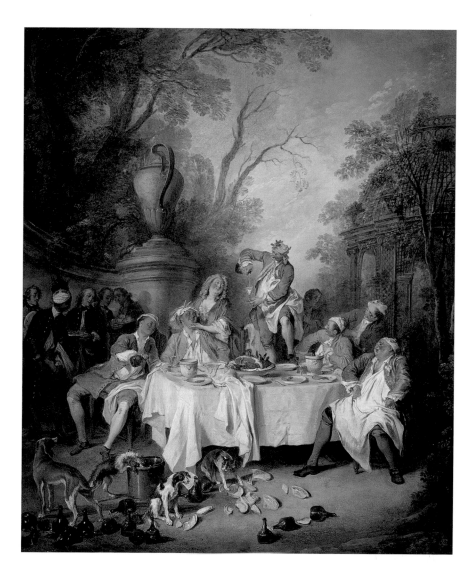

FIGURE 3
Nicolas Lancret, *Luncheon Party in a Park*, 1735. Oil on canvas, 54.1 × 46 cm (21⁵/₁₆ × 18¹/₈ in.). Boston, Museum of Fine Arts, Bequest of Forsyth Wickes— The Forsyth Wickes Collection, 65.2649.

FIGURE 4

Nicolas Lancret, *The Picnic
After the Hunt*, circa 1735–40.
Oil on canvas, 61.5 × 74.8 cm
(24 1/8 × 29 3/8 in.). Washington,
D.C., National Gallery of Art,
Samuel H. Kress Collection,
1952.2.22.

FIGURE 5

Nicolas Lancret, *Autumn*,
circa 1721–23. Oil on canvas,
113 × 94 cm (44 1/2 × 37 in.).
Amenia, New York, courtesy
of the Homeland Foundation,
Incorporated.

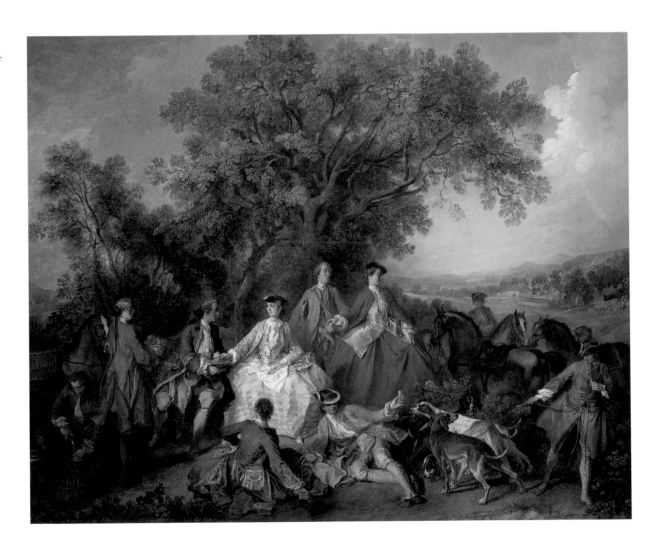

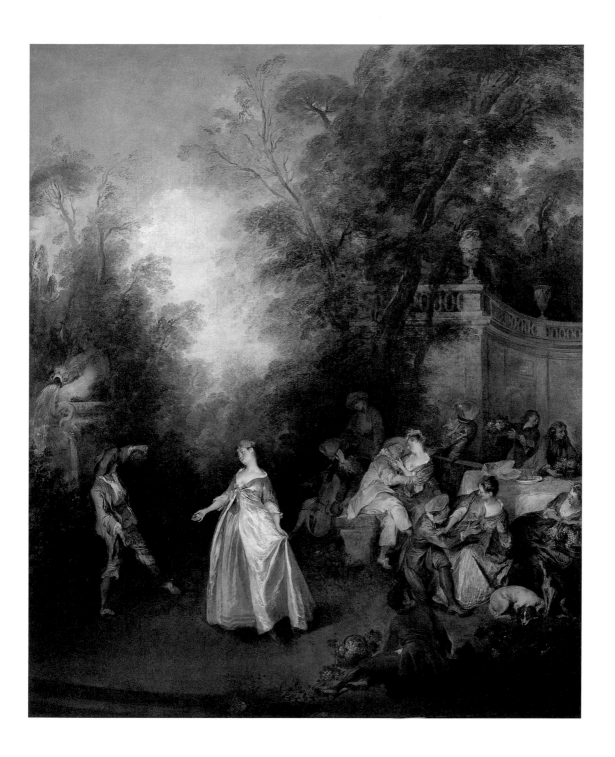

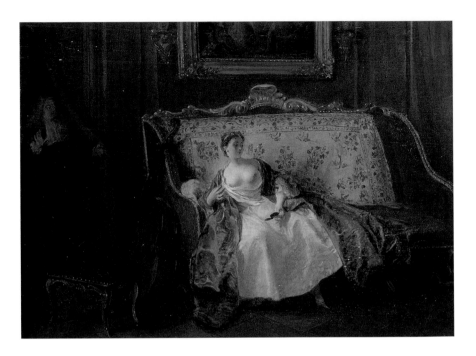

6

magnificent *Autumn* (since Mr. Stillman's death, in his Homeland Foundation) [FIGURE 5] was made for Leriget de la Faye, one of Lancret's most important early patrons, and a small masterpiece on panel, *Young Woman on a Sofa* [FIGURE 6] is in a private collection in Los Angeles. Other fine examples in private collections in the United States include *Outdoor Concert with the Beautiful Greek and the Amorous Turk* [FIGURE 7] and *Concert in a Salon with Architectural Decoration*.[4] Nonetheless, this group is a paltry sampling from an artist whose productivity was legendary, and who painted, at a conservative estimate, several hundred works. It is thus with gratitude, and no small sense of relief, that we welcome a Lancret of such grandeur to this country. In addition to its obvious beauty and appeal, the painting reveals a remarkable amount about this painter, his mode of painting, Paris at the time this work was made, eighteenth-century dance, and the world of art patronage and collecting in France and elsewhere in the eighteenth and nineteenth centuries. It is these revelations that this book will attempt to discover and describe. The beauty speaks for itself.

FIGURE 7
Nicolas Lancret, *Outdoor
Concert with the Beautiful Greek
and the Amorous Turk*, circa 1721.
Oil on canvas (oval),
59 × 75 cm (23¹/₄ × 29¹/₂ in.).
New York private collection.

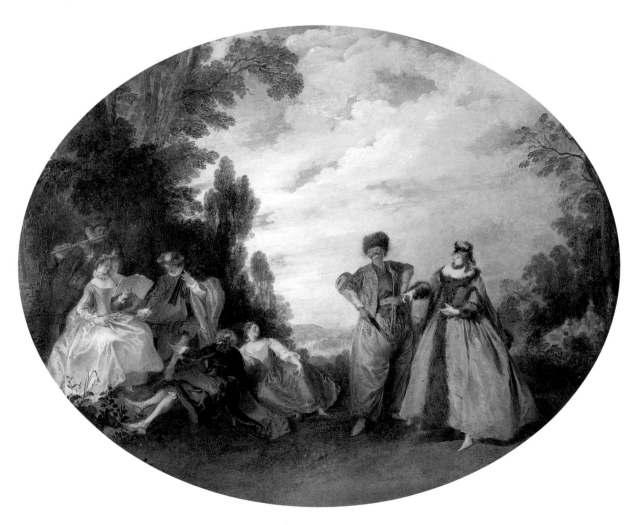

8 FIGURE 8

Nicolas Lancret, *Dance Before a Fountain* [detail of Figure 1].

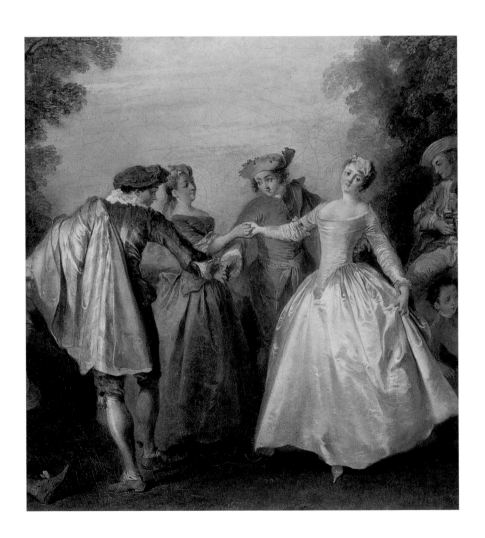

THE PAINTING

IN THE GENTLE LIGHT OF A GARDEN GLADE, A MUSICAL PARTY arranges itself in the clearing in front of a noble fountain. The party revolves, both figuratively and literally, around the elegant figure of a dancing woman placed nearly in the center of the painting. She is set off by her central location, her lustrous pearly white dress, and her pose, facing the viewer and performing a graceful step, at once inviting the viewer to the dance and introducing herself as The Dancer. Her pure white dress is relieved by one touch of color, the discreet lavender ribbon on her sleeve. In her immediate space, she forms part of a dancing foursome, but she is its queen, and the other dancers orbit around her as planets rotate around a sun [FIGURE 8]. In this quartet, the dancers each extend one arm across the center to link hands, right hand to right hand, woman to woman and man to man, to form the windmill shape that gives the painting its twentieth-century nickname, *Le Moulinet*, or "the mill." The woman in white is doubtless paired with the man with a beret and ruff seen from behind, who is clad in gorgeous and theatrical silks, his salmon, blue, and lemon cape flung confidently to one side to free his arm for the dance step, and his muscular, bestockinged legs in graceful poise. This pair is urban, their silks revealing them as the city folk in this dance. Their country counterparts are no less graceful, if dressed somewhat less spectacularly. The woman in the back is a plain beauty in a simple and subdued costume. The piquant hat provides much of her charm. The next dancer is her partner, a man in country brown, wearing a straw hat edged with leaves. He too has cast aside his

FIGURE 9

Nicolas Lancret, *Dance Before a Fountain* [detail of Figure 1].

cape to better perform the dance. The four are silhouetted against a brilliant blue sky, a sky gently sketched with the pink stripes of impending sunset and marked with a few pillowy clouds. It is the gentle light of early evening, *l'heure bleu*, the time for love. The dancers are framed on both sides by nodding trees.

Disporting around this main group is a party of some sixteen people and two dogs. A small gathering of three is to the left of the dancers. A seated man in brown with blue leggings forms the *repoussoir* bookend for the left side of the painting. Behind him sits a girl in orange-red silk trimmed in silver, calmly fanning herself as she ponders the attentions of the beautiful long-haired boy so intent on explaining himself. Just

behind the dancers is one of the two musicians in the painting, a beribboned musette player.[5] Next to him is a charming couple, a girl in citron yellow with a straw hat set rakishly to one side of her head, who is talking things over with her partner, the natty man in red with a ruff and beret. He embraces her from behind [FIGURE 9].[6] Just visible over his left shoulder are two women farther into the foliage, one of them holding the staff of a pilgrim, a delicate reminder that all lovers are pilgrims to Cythera, the island where Venus was born. At the feet of the girl in yellow is a delicately rendered boy in brown with red heels on his shoes, this possibly a gentle allusion to his role as courtier in this court of love.[7] He sits in the subtle shadow of the white dancer, except for his left hand, where light falls directly. A massive fountain, created in grisaille to mimic stone and sculpture, anchors the scene on the right [FIGURE 10]. The fountain has a central niche containing a lobed basin with a *jet d'eau* in the center, the water spilling over the sides of the basin. The side niche, which demands a matching niche on the other side outside the canvas boundary, is flanked by Tuscan columns on pedestals and topped by a river nymph who reclines on her emblematic urn spilling water. She gazes down at the assembled mortals. She too must have a mate, not visible within the scope of the painting. On the base of one of the pedestals sits a delicate lady all in pink with a white lace kerchief, being intensely courted by a bowing man in brown. He leans into her, his hand on her arm. He wears a tunic with a stripe at the hem, and a leather strap crosses his back; he must be another pilgrim, and the strap must hold a water bottle. Just in front of the woman is a dashing man in dark red with heavy-lidded eyes; one hand on hip, satin beret in hand, wearing a

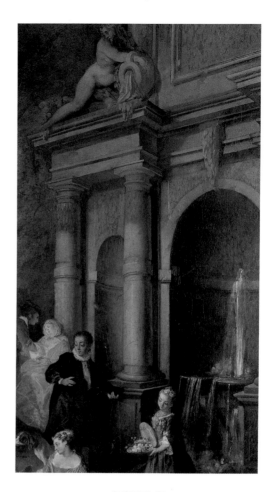

FIGURE 10
Nicolas Lancret, *Dance Before a Fountain* [detail of Figure 1].

handsome black dressing coat and a ruff at the neck, he is distinguished by his dark costume and single status, his air of detachment.[8] He watches with interest the courtship of the couple at his feet, the woman in gold seated on the ground, showing her fan to the guitarist in brilliant blue reclining in her lap. Is there a painting for him on that fan? Their courtship is mimicked hilariously and sweetly in the figures of the two brown-and-white hounds just behind. The male dog is all attentive urgency, ears forward, as he yearns toward the female dog, who has turned to look at him. To the right of the guitar couple is a pyramid of four children [FIGURE II], the oldest standing, already mature and graceful in her sea-green dress and pink lacy fichu, holding a basket of flowers picked this day in the garden. The three younger ones nestle together on the ground. One, her back to us, is clad in a fantastic purple striped dress laced up the back. There is a long, loose leash attached to the back of her dress to help control her wanderings. Her soft blond hair is topped by a small lace cap. She holds something in her lap that is intensely interesting to the other two children, who strain to get a good look. It must be a bird's nest or the like, something she found in her garden play, much as her older sister collected her flowers. These youngest children are all innocence, entirely uninvolved in the courtship rituals of the older members of their party; the older child, though, is standing on the edge of the action in the painting, and on the brink of her maturity. Not yet a participant, she is preparing to be, and gathers her flowers before they fade.[9]

THE "FÊTE GALANTE"

THIS PARTICULAR PAINTING BELONGS TO A CATEGORY OF SUBJECT known as the *fête galante*, or "gallant party." A *fête galante*, as the term is applied to an image, depicts a gathering of attractive people in a cultivated landscape or garden, engaged in leisure activities such as dancing, playing music, picnicking, swinging, picking flowers, strolling, chatting, and flirting; to use Sarah Cohen's nice phrase, to "appear both naturally interactive and threaded together by artifice."[10] As we have seen, many of these activities can be found in the Getty Museum's Lancret painting [FIGURE I]. The fountain indicates that the location is cultivated; in other words, not a forest. The main activities of the participants are dancing, flirting, playing music, and picking flowers. The *fête galante* was created by Jean-Antoine Watteau (1684–1721) and reached its peak of popularity in the first half of the eighteenth century in France, the period and place in which this work was painted. A long history of influential visual antecedents existed for this new type, however, going as far back as medieval manuscript illumination and love garden imagery.[11]

The most direct sources of inspiration for the genre were from the seventeenth century, especially in the Netherlands.[12] Influential works included paintings of merrymaking companies (*vrolijk gezelschap*) and garden parties (*buitenpartij*) by artists such as Dirck Hals (1591–1656), David Vinckboons (1576–1632), Adriaen van de Venne (1589–1662), and Willem Buytewech (circa 1591/2–1624); images of glamorous gatherings and balls by Hieronymus Janssens (1624–1693), and the crucial contribution of Peter Paul Rubens, especially *The Garden*

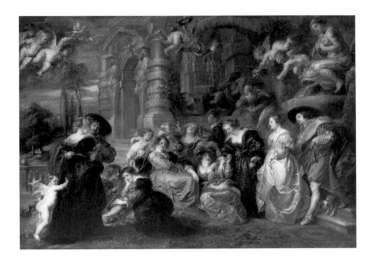

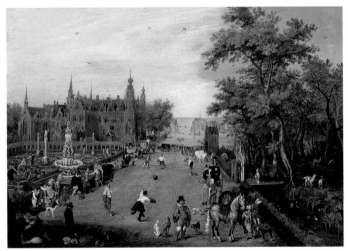

FIGURE 12

Peter Paul Rubens (Flemish, 1577–1640), *The Garden of Love*, circa 1632–34. Oil on canvas, 198 × 283 cm (78 × 111³/₈ in.). Madrid, Museo del Prado.

FIGURE 13

Adriaen van de Venne (Dutch, 1589–1662), *A Jeu de Paume Before a Country Palace*, 1614. Oil on panel, 16.5 × 22.9 cm (6¹/₂ × 9 in.). Los Angeles, J. Paul Getty Museum, 83.PB.364.2.

of Love now in the Prado [FIGURE 12]. In this last work, as Elise Goodman notes, we find "the garden as a setting for courtship and amorous dalliance."[13] In Van de Venne's *A Jeu de Paume Before a Country Palace* [FIGURE 13] in the Getty collection, we find the well-dressed couples, the games and leisure activities, and the garden setting, and in Rubens's work, the exuberant coupling of aristocrats.

The seventeenth- and eighteenth-century French print tradition had a role to play as well, especially the trade scenes, role pictures

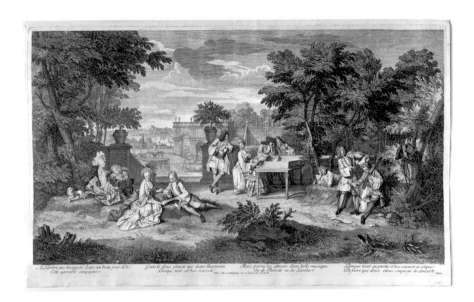

FIGURE 14
Bernard Picart (French,
1673–1733), *A Concert in a Park*,
1709. Engraving. Versailles,
Château de Versailles et
de Trianon.

FIGURE 15
Claude Simpol, *Le cavalier
achetant de dentelles*, circa 1696–98.
Engraving. Photo taken from
Hélène [de Vallée] Adhémar,
"Sources de l'art de Watteau—
Claude Simpol," *Prométhée* 3
(April 1939), p. 69.

15

(a single actor or actress in a theatrical costume), and
fashion plates—the *gravures de mode*.[14] There the artists of
the *fête galante* found a nearly limitless supply of stylish
people in fashionable and contemporary dress, often
pursuing the sort of leisure or activities that could trans-
late more or less directly into the eighteenth-century
paintings. Many artists were involved in the designing,
engraving, editing, and publishing of these mass-market
prints. Abraham Bosse (1602–1676) is the best known,
but there were others of importance as well.[15] One has
only to see Bernard Picart's *Concert in a Park* engraving of
1709 [FIGURE 14] or Claude Simpol's *Le cavalier achetant
de dentelles* [FIGURE 15] to note the obvious similarities.
These prints provided a valuable and consistent
resource for the creators of the *fête galante*.

It has often been noted by scholars in the field[16]
that the *fête galante* was, in its essential elements, a real
activity in seventeenth- and eighteenth-century France,
une resjouïssance d'honnestes gens (a rejoicing or enjoyment

of honorable or respectable people).[17] Well-bred people gathering outdoors to socialize, flirt, picnic, and dance was a relative commonplace of both centuries, and descriptions abound of these parties in the gardens of the Luxembourg Palace, at Versailles, at the noble house of the duc and duchesse du Maine at Sceaux or the duc de Vendôme at Anet, or in the Bois de Boulogne. Before the end of the seventeenth century, such social gatherings even began to be called *fêtes galantes*. As Sarah Cohen points out, "At least since Louis XIV's *Plaisirs de l'Isle enchantée* [1664, *Fête of the Enchanted Isle*] the term *feste galante* [an older French spelling of *fête galante*] had designated royal spectacles and parties and was now appearing both in the theater and in descriptions of Parisian gatherings. . . ."[18] According to Madeleine de Scudéry (1607–1701) in her *Promenade de Versailles* (Paris, 1669), for example, "C'est assurement une belle et agréable chose de voir le Roy en ce beau desert, lorsqu'il y fait des petites festes galantes ou de celles qui étonnent par leur magnificence."[19] One could go on, but suffice it to say that both the festive activity and the term were well established by the time the designation of *fête galante* was used to describe a painting.

Another defining aspect of the *fête galante* is its close relationship to contemporary theater.[20] Together with sources in the fine arts and real-life fêtes, the theater forms the third essential formative component of the genre. The theater of early eighteenth-century France had enormous variety, and the numerous dramatic forms all contributed to the development and context of the *fête galante*. However, the Italian theater is the main source for imagery of the *fête galante*.

The Italian Comedians, or *commedia dell'arte* actors [FIGURE 16]—those repertory players who count Harlequin, Scapino, Columbine, Mezzetin, Dottore, Pantaloon, Polichinelle, Scaramouche, and Pierrot among their characters—had a Paris home at the Hôtel de Bourgogne in Les Halles until 1697 when, in an oft-told episode described in a lost painting by Watteau, they were expelled for insulting the morganatic wife of Louis XIV, the pious Madame de Maintenon. They did not vanish from the scene, however, but merely relocated to the nearby fairs—the

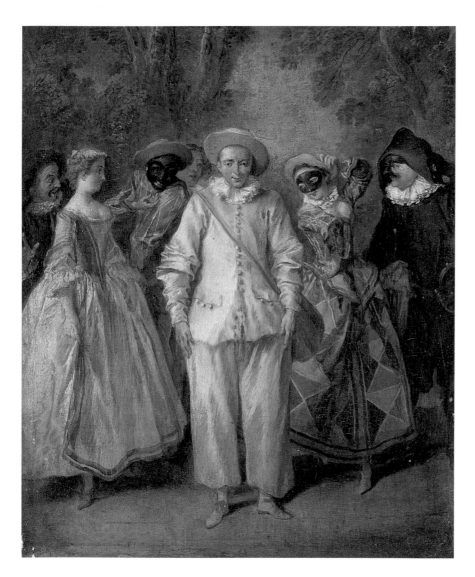

FIGURE 16 17

Nicolas Lancret, *The Italian Comedians*, circa 1724–28. Oil on panel, 15.5 × 22 cm (6⅛ × 8⅝ in.). Paris, Musée du Louvre. Photo: H. Lewandowski.

Foire Saint-Germain in spring and the Foire Saint-Laurent in autumn—and retooled their repertory to suppress the now-outlawed spoken word and to feature mime. On the invitation of the regent, the duc d'Orléans, the Italian Comedians returned to Paris to their old location in 1716; but this was a new troupe from Parma, and the fair

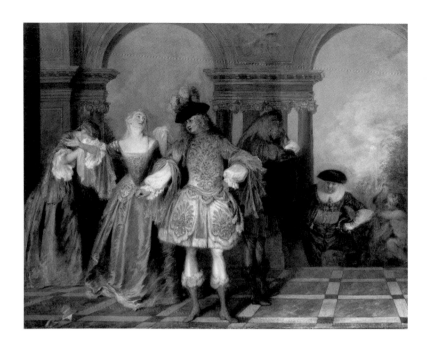

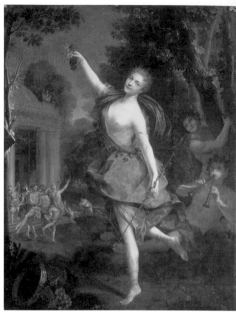

FIGURE 17
Jean-Antoine Watteau
(French, 1684–1721),
The French Comedians, 1720–21.
Oil on canvas, 57.2 × 73 cm
(22¹/₂ × 28³/₄ in.). New York,
Metropolitan Museum of Art,
Jules Bache Collection, 1949,
49.7.54.

FIGURE 18
Jean Raoux (French,
1677–1734), *Portrait of Mademoiselle
Prévost as a Bacchante*, 1723.
Oil on canvas, 209 × 163 cm
(82¹/₄ × 64¹/₈ in.). Tours,
Musée de Beaux-Arts.

troupes continued. They found their way, too, to the country houses of the nation's cultural and social elite, who staged masquerades and parades with the participation of the actors in costume.[21]

The legitimate spoken-word theater was the province of the Comédie-Française [FIGURE 17], located since 1689 on the rue des Fossés Saint-Germain on the Left Bank, with Café Procope across the street. Musical theater was the specialty of the Opéra [FIGURE 18], which had been located in the old Palais-Royal theater since 1673. Its eighteenth-century repertory was considerably enlivened by the creation of opera-ballets, with entrées separated by danced divertissements.

Theater and dance imagery from these various worlds made their way into paintings, drawings, and prints especially via the work of Claude Gillot (1673–1722), who served as a critical conduit between the visual and performing arts [FIGURE 19]. Active in Paris as early as 1695, Gillot produced theater and commedia scenes, as well as costume and set designs, arabesque decorations, and book illustrations. He drew his inspiration largely from the Spectacles de la Foire following the

expulsion of the Théâtre Italien in 1697. Characters drawn from the theatre would become a routine and essential part of the population of the *fête galante*.

 One artist brought together all the sources, binding and transcending them, creating *fêtes galantes* that one scholar has called "allegories of desire." It was in fact in reference to this artist's work that the term *fête galante* was first used to categorize an artistic theme. The artist was Jean-Antoine Watteau and the time about 1715, when, as Donald Posner describes it, "Watteau crossed the boundary that in art separates men of high professional competence, and even originality, from those geniuses who are able to create new worlds of vision."[22] The *fête galante* is such a "new world," and the simple listing of the separate elements that

FIGURE 19
Claude Gillot (French,
1673–1722), *"Arelequin esprit follet":*
The Comedians' Repast, circa
1704–18. Pen and black and
red ink, and brush and red wash,
on tan laid paper, 15.7 × 21.2 cm
(6 1/8 × 8 3/8 in.). Chicago, Art
Institute, restricted gift of Dr.
and Mrs. William D. Shorey,
1986.408.

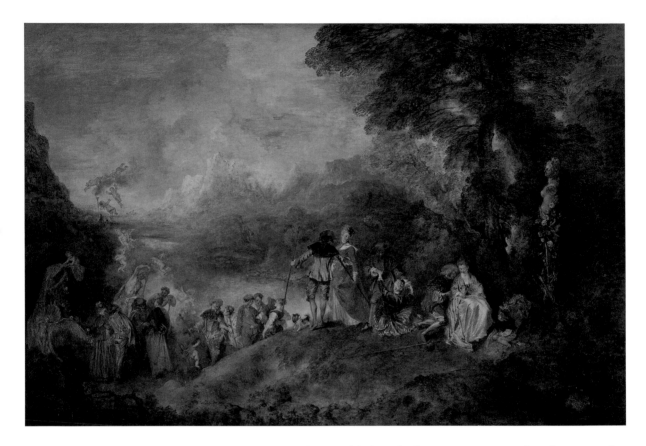

20

combine to make this world does little to prepare one for the astonishing result. In Watteau's sure hands, in a masterpiece such as the 1717 *Pilgrimage from the Island of Cythera* [FIGURE 20], the distinct notes are expertly and fluidly orchestrated, related by position, gesture, touch, and glance, in a rhythmic search for that most elusive prize of all art, the description of the workings of the human heart.

The name used to characterize these paintings, like so many other art-historical designations (most famously "Impressionism"), probably did not originate as a compliment, but as a "felicitous expedient in dealing with the dilemma of classifying Watteau's painting."[23] Watteau was accepted as a candidate for membership in the Académie Royale de Peinture et de Sculpture (Royal Academy of Painting and Sculpture) on July 30, 1712. As a candidate, he would be required to submit a reception piece to achieve final membership status. The usual practice was for

Academy members to assign a theme for the reception piece, but in Watteau's case it was left up to the artist—"à sa volonté," to his pleasure.[24] One can imagine that the academicians, whose methods of understanding and categorizing art were still defined by the hierarchy of genres (with history painting, which would include mythology and religion, at the top level of achievement and recognition, then portraiture, with scenes of everyday life, or "genre," landscapes, and still lifes at the bottom[25]), were confused somewhat by the subject that Watteau was presenting, which was neither fish nor fowl, and perhaps at a loss to suggest an appropriate reception theme. This same confusion can be seen in their search for a correct title for their minutes when, after much delay, Watteau finally turned in his reception piece (*morceau de réception*) on August 28, 1717. The Academy recorded the work first by its subject, "le pèlerinage à l'isle de Cithere" [a pilgrimage from the island of Cythera], then crossed that out and replaced it with "une feste galante."[26] A new theme had been born in Watteau's work in the decade of the 1710s, and having been born, now gained a name.[27] The second time the phrase "une feste galante" would be used to describe the theme of a painting was on March 24, 1719, in the minutes of the Academy registering the acceptance of Nicolas Lancret.

Thus was the *fête galante* created, and its chief attributes established. But for all Watteau's brilliance and influence, appreciation of his work remained largely in the province of the sophisticated connoisseur.[28] Genre painting was about to emerge onto a much larger stage, with patronage and status it had never possessed theretofore. Another kind of vision would be needed to move Watteau's "new worlds" into the modern world.[29] That vision belonged to Nicolas Lancret. Lancret possessed a complete understanding of Watteau's novel genre, and of the public art taught by the Académie Royale. He was able to marry these parallel views in works of art with genre as their subject and the grand visual manner of history painting as their backbone. It is a very powerful combination, one that carried Lancret's works to walls where previously only history themes had held sway.[30]

Non, ce n'est pas un poëte que Lancret, c'est un prosateur elegant.[31]

NICOLAS LANCRET (1690–1743) WAS ONE OF THE MOST IMPORTANT and appealing genre artists at work during the first half of the eighteenth century in France, an age that saw a remarkable rise in the variety and importance of genre. The term *genre painting* refers specifically to the painting of everyday or common life, and it is a term that came into widespread use for this purpose only in the nineteenth century. It was little used by eighteenth-century authors on the fine arts, who preferred terms such as "painter of a particular talent," "painter of a familiar scene," or, most commonly, "painter of *bambochades*," a reference to the seventeenth-century genre scenes made in Rome by Pieter van Laer (1599–circa 1642, known as "il Bamboccio") and his followers.[32] While it is true that at the Academy and among the critics, the hierarchy of genres remained firmly in place during Lancret's lifetime and after, it is important to point out that the Academy was becoming a much more congenial place for practitioners of the lesser genres, and the critics more accepting.

Lancret's role in this development was a crucial one. He was a steadfast member of the art establishment all his working life, eventually attaining the Academic rank of *Conseiller dans les talens particulier*, the highest rank available to a non-history painter and the rank held by Jean-Siméon Chardin (1699–1779) just after him. His style represented a conscious merging of genre subject matter with formal elements

common to history painting. During his lifetime, he dominated the genre scene with an enormous production of paintings and prints. He counted among his patrons many of the royal families of Europe, as well as major collectors among the aristocracy and in the financial community. He was a favorite genre artist of Louis XV, who commissioned decorations from him for most of the Crown residences. Lancret's sole rivals in the scope and scale of commissions for royal decorations— François Boucher (1703–1770), François Lemoyne (1688–1737), and Jean-François de Troy (1679–1752)—made most of their contributions in the area of history painting; their genre work was a side effort. Lancret was entirely a genre artist, and the only one so employed. This distinction also sets him apart from Watteau and Chardin, the two genre artists often considered the most significant of his day; they neither sought nor gained the kind of royal patronage that Lancret won consistently.

Lancret was an important factor in the shift of perception that moved genre from the wings to center stage in French art. He had a rare opportunity, living and painting at a moment when the standards of excellence in art were changing and expanding. History painting (that painting which takes as its subject any narrative from history, mythology or the Bible, and which traditionally aspires to a correspondingly grand stylistic manner as well), hitherto foremost in esteem and patronage, no longer suited all the needs of a growing market. This change allowed painters of genre to gain wider acceptance, and Lancret's work was crucial to that effort. By the end of his career, genre ranked below history painting only in the minds of academics, not on the walls of patrons.

The reasons for Lancret's popularity and success are easy to appreciate. His pictures tell lively and intelligible stories, his themes are inventive and amusing, and his colors and color combinations are bright and striking. His works combine the contemporaneity of the fashion print and the humorous, anecdotal quality of the then-emerging novel form with a naturalism and grace [FIGURE 21] learned from the lyric example of Watteau [FIGURE 22]. Lancret's images made the transition from decorative painting to engraving with ease, and then went on to

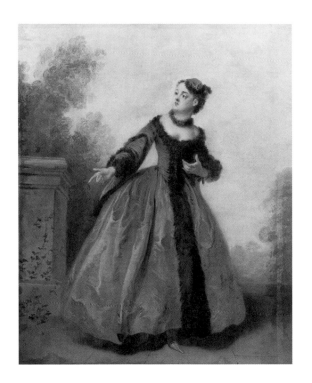

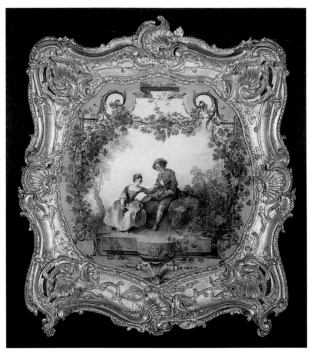

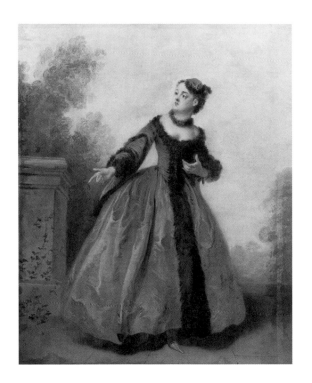

FIGURE 21

Nicolas Lancret, *La Belle Grecque*
(The Beautiful Greek), circa 1735.
Oil on canvas, 68 × 56.7 cm
(26 3/4 × 22 3/8 in.). London,
Wallace Collection, P450.

FIGURE 22

Nicolas Lancret, *Autumn* (from
a set of four overdoors of the
Four Seasons, contour shape),
circa 1723. Oil on canvas. Sale,
Christie's, New York, November
1991. Private collection. Photo
courtesy Christie's Images.

capture the popular imagination in much the same way as tasty gossip,
with a rich broth of contemporary detail flavored by intimate and comic
insight.[33] His paintings are steeped in eighteenth-century life—its style,
amusements, personalities, secrets, and jokes. He married convincing
description to legible narrative, creating a concrete, comprehensible
image. Early on, Lancret abandoned Watteau's delicate ambiguity, pre-
ferring a style with the visual power and narrative coherence of history
painting, one that could carry when seen above the highest doorway
[FIGURE 23]. Robust faces with vivid expressions, broad gestures, and
figures close to the picture plane characterize his mature work.

 A telling example of Lancret's signature manner and his prodi-
gious success is *Luncheon with Ham*, which survives in two versions: the first
one, painted for Louis XV in 1735, is now in Musée Condé at Chantilly
[FIGURE 24], and the second, Lancret's reduced replica [see FIGURE 3],
once owned by renowned collector of contemporary French art Ange-
Laurent de La Live de Jully (1725–1779), is now in the Forsyth Wickes

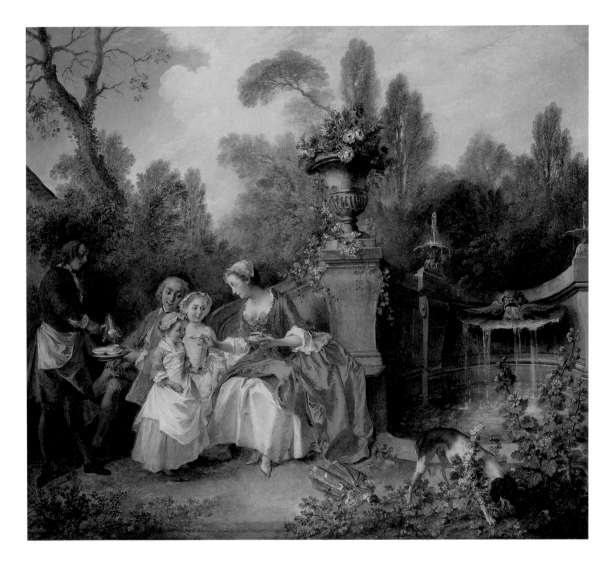

Collection at the Museum of Fine Arts, Boston. This boisterous work must have greatly amused the king, himself famously a fan of hunting and of the informal nature of private meals afterward. The actions of the jolly hunters, whose ruddy features are heightened by the removal of their wigs, are cleverly aped by the greedy satyr and hound in the sculptural group behind them (an urn in the La Live de Jully version). The figures are close to the picture plane, and the colors, ranging from the

FIGURE 23

Nicolas Lancret, *A Lady in a Garden Taking Coffee with Some Children*, circa 1742. Oil on canvas, 88.9 × 97.8 cm (35 × 38½ in.). London, National Gallery, 2451. Photo © National Gallery Picture Library.

26

FIGURE 24

Nicolas Lancret, *Luncheon with
Ham*, 1735. Oil on canvas,
188 × 133 cm (74 × 52⅜ in.).
Chantilly, Musée Condé. Photo:
Lauros-Giraudon/Art Resource,
New York.

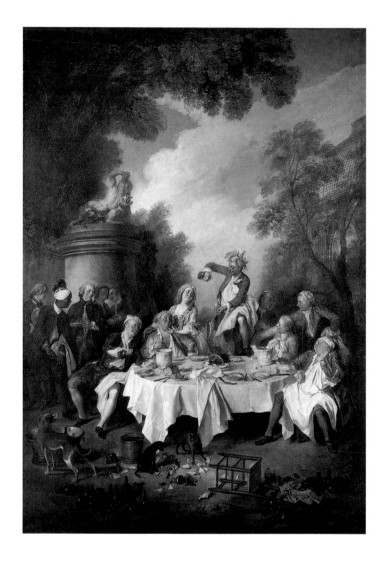

greens and blues of the coats to the rose of the ham, are vivid and lumi-
nous. One of the most impressive features of both versions is the splen-
did still life on the table, which rivals the work of a still-life specialist and
is an unexpected—and unheralded—aspect of Lancret's abilities. The
blaze of white linen, glistening silverware, and blanc de chine Saint-
Cloud porcelain wine coolers brings to mind Jean-Baptiste Oudry's
dictum that the good still-life painter is one who can compose a work

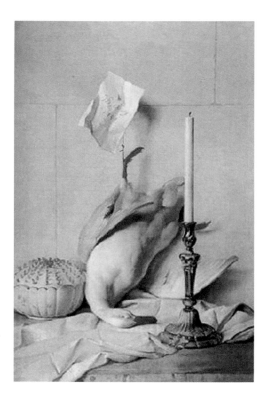

entirely of white objects and manage to give each item its due—which Oudry accomplished in his tour-de-force, *The White Duck* [FIGURE 25].

Lancret was thus a strikingly successful and appealing artist who helped establish genre painting as a legitimate endeavor in France and whose prints ensured its long-lasting popularity in Europe well after his death. Ambitious and prolific, he helped secure the future for artists such as Jean-Baptiste Greuze (1725–1805) [FIGURE 26], Louis-Léopold Boilly (1761–1845), and even William Hogarth (1697–1764), all of whom prospered in his wake. But that is not the whole story. The visual charm and narrative strength of Lancret's paintings were augmented by sophisticated imagery; among his most important contributions to genre are his thematic ingenuity and his expansion of the vocabulary of genre scenes. Lancret's tableaux tell their tales not only through the gestures and expressions of their characters but also through a variety of conceits and motifs—among them traditional allegory, iconographic staffage, and even persuasive colors—that enriched his narratives for his sophisticated and literate audience [compare the skate motif in FIGURES 27 and 28]. If superficially the works retain the appearance of genre, they are supported by an underpinning of iconography. Of course, this touch of intellectual rigor moved Lancret closer to history painting. He showed that such discipline need not accompany only themes of great moral or philosophical import; it could be put as well to the service of charm and wit. Colin Bailey recently commented on the ability of eighteenth-century genre artists to enhance their work in this way: "With its use of symbols and allusions, genre painting is no less multivalent than history; but it is the

27

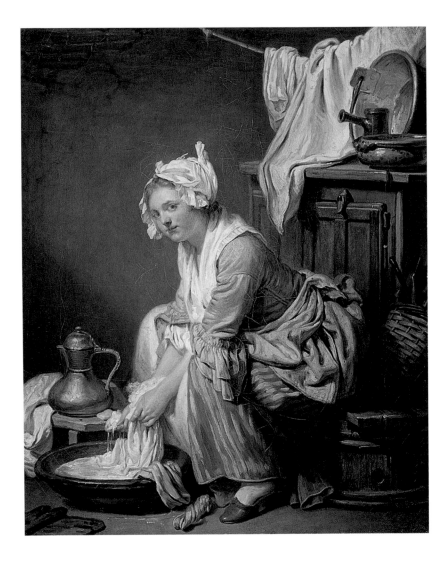

FIGURE 26
Jean-Baptiste Greuze (French,
1725–1805), *The Laundress*, 1761.
Oil on canvas, 40.6 × 32.4 cm
(16 × 12⅞ in.). Los Angeles,
J. Paul Getty Museum,
83.PA.387.

engagement with the real that defines its practices and offers the possibility of renewal."[34]

Lancret's life was not as exciting as his art.[35] A hardworking man who never left Paris, he possessed an even temperament quite unlike that of his mentor, Watteau, or of his closest friend, the tragic suicide Lemoyne. Lancret was born in Paris on January 22, 1690, to parents of the artisan class; his father, Robert Lancret, was a coachman, and his mother, Marie-Catherine Planterose, was the daughter and sister of cobblers. Nicolas first apprenticed with an engraver and drawing master whose name is not known; he then joined the atelier of Pierre Dulin (1669–1748), a history painter

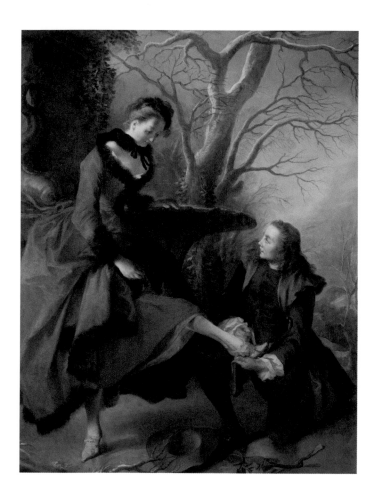

who modeled his art on the example of Charles Le Brun
(1619–1690), first painter to Louis XIV. Dulin is prac-
tically unknown today; indeed, even in 1762, biogra-
pher Dezallier d'Argenville termed him a "mediocre
history painter." Twenty-one years Lancret's senior, he
is found in histories of seventeenth-century French
painting. The combination of ideal types with Baroque
effects that marks his *Annunciation* in Arras clearly links
him with Le Brun, as does his reception piece of 1707,
the *Leonidas* now at the École des Beaux-Arts, Paris.

Although Dulin's work had little in common with Lancret's future manner, Nicolas must have received sound training in his atelier. Dulin had entered a well-established painting family by marrying the daughter of the history painter Charles-Antoine Hérault, placing himself in the midst of a lively artistic circle that included Nöel Coypel, Louis de Silvestre, and Jean II Bérain. It must have been an exciting milieu for a young painter, and Lancret later spoke of Dulin as having been very important to him.[36] The exact dates of Lancret's early training are unknown, but presumably they fall within the first decade of the 1700s, his teenage years. Georges Wildenstein, in *Lancret*, his 1924 monograph on the artist, places the lessons with the drawing master around 1703 and the entry into Dulin's studio around 1707, and this chronology must be reasonably close to the mark.[37] Lancret is first mentioned in the records of the Académie Royale de Peinture et de Sculpture on September 28, 1708, as being already registered in the course of training there.[38] He would become a lifelong and active member of the Royal Academy after his acceptance, eventually attaining the rank of *Conseiller* (counselor) in 1735.

Lancret, like all students of the Academy, received the training of a history painter. There is no indication in his early days—roughly 1700 to 1710—of an inclination toward genre of any sort. The first signal of a change in direction was Lancret's decision to enter the shop of Claude Gillot, a prolific draftsman and genre painter specializing in fairground and theatrical subject matter [FIGURE 29]. Exactly when this took place cannot be established; Lancret's eighteenth-century biographers report merely that he joined Gillot after leaving Dulin. What prompted his decision? We can only speculate, but a combination of motivations seems most likely. To begin with, Lancret might have been drawn to the new kind of painting that Watteau had introduced. Ballot de Sovot and Dezallier d'Argenville both insist that Lancret's move to Gillot's workshop was a turning toward the taste of Watteau, which had become very popular.[39] Watteau's reputation spread only after 1712 with the presentation of several paintings to the Academy, including one of his earliest commedia dell'arte scenes in the *fête galante* mode, *The Jealous Ones*.

FIGURE 29

31

Claude Gillot, *The Two Coaches*
(Les Deux Carrosses) (Scaramouche and
Harlequin, in disguise, cursing each
other; scene added to the comedy
"La Foire St. Germain" of 1695),
circa 1707. Oil on canvas,
127 × 160 cm (50 × 63 in.).
Paris, Musée du Louvre,
RF 2405. Photo: Arnaudet.

Another factor in Lancret's decision must surely have been the new level of popularity and acceptance achieved by genre painting. In France, the marketability of genre had never been stronger. Wealthy and influential patrons, including Louis XV, were buying genre paintings, especially those by Dutch, Flemish, and French artists. Even the Academy, traditionally a bastion of idealism, began to accept and incorporate the lesser genres more enthusiastically.[40]

Even if Lancret's move to Gillot's studio did not reflect in itself a commitment to genre painting, surely these factors affected his ultimate decision to take up the genre of the *fête galante*. The inspiration of Watteau's innovation and success of 1712, and the promise of a more secure academic and financial future, prepared the way for his decision.

It is also conceivable that Lancret's entry into Gillot's shop was motivated by more immediate practical concerns. Perhaps he needed extra money and took a job as Gillot's assistant simply to augment his income. The two artists could easily have met at the Academy. Perhaps

32 FIGURE 30
Nicolas Lancret, *Gallant
Conversation*, circa 1719.
Oil on canvas, 68.3 × 53.5 cm
(26⁷/₈ × 21¹/₈ in.). London,
Wallace Collection, P422.

after Watteau brought popularity to the commedia dell'arte theme in 1712, Gillot decided to enlarge his shop to capitalize on the new commercial success of such scenes. Trained at the Academy himself, Gillot would naturally seek help there.

However and whenever Lancret entered Gillot's studio, the step was to prove definitive; in 1719, Lancret presented the Academy with a painting in the genre of a "une Feste galante," a term that, as we have seen, had been used to describe Watteau's contribution only two years earlier. His reception piece, *Gallant Conversation*—probably the painting now in London in the Wallace Collection [FIGURE 30]—was accepted on March 24, and Lancret was *reçu*, received as a full member.[41] This painting is close in theme and style to works by Watteau, such as *Harlequin and Columbine* [FIGURE 31], also in the Wallace Collection. Ballot de Sovot, Lancret's friend as well as his biographer, said it best in describing two paintings made by Lancret the previous year for preliminary acceptance (*agréement*) to the Academy: "The two paintings are certainly in the genre of Watteau."[42] Lancret's period of closest stylistic and thematic resemblance to Watteau can be found in these early works.

After the deaths of Watteau in 1721 and Gillot in 1722, Lancret became one of the public inheritors of the new genre, with a great opportunity for success in his chosen arena. The popularity of the *fête galante* among connoisseurs was by then well established. It was an exciting and lucrative new mode of expression, and Lancret was well able to cater to the demand for it, while introducing the innovations of style and theme that would mark his independence. By 1719–20, Lancret was achieving the kind of independent work that would prompt Ballot to insist that, although Lancret and

33

FIGURE 31
Jean-Antoine Watteau, *Harlequin and Columbine (Voulez-vous triompher des Belles? [Do You Want to Succeed with Women?])*, circa 1717.
Oil on oak panel, 36 × 24.9 cm (14 1/8 × 9 3/4 in.). London, Wallace Collection, P387.

Watteau had much in common, the "true connoisseurs will not confuse them."[43] Lancret was thirty-one at the time of Watteau's death, a mature artist in full possession of the skills and imagination necessary to gain and excel at the most important commissions.

THE EXPOSITION OF YOUNG PAINTERS

LANCRET'S FIRST PUBLIC FORAY AFTER HIS ACCEPTANCE INTO THE Academy came at the annual Exposition de la Jeunesse, where he showed his work dating from at least 1722. Lancret and his fellow relative unknowns had few chances to display their work to the public in the 1720s. Since the turn of the century, the Academy had sponsored only one official Salon, in 1704. With such scant opportunity, Lancret turned to an unofficial arena to exhibit his work. The Exposition de la Jeunesse, which must have seemed a crucial opening to a newly minted academician, was held each spring on one day only—the *Fête-Dieu*, or Feast of Corpus Christi—outdoors on the Place Dauphine and the Pont Neuf. It did not carry the prestige of an Academy show, and history painters generally ignored it. Although the earliest record of Lancret's exhibiting there dates from 1722,[44] he seems to have done so at least once before Watteau's death in 1721.[45] This activity stopped after his work appeared in the official Salon of 1725, but he showed numerous fine works at the Exposition.[46]

The *Quadrille Before an Arbor* [FIGURE 32], now in Charlottenburg Palace, was probably among the entries for 1724; the *Mercure de France* described it as "dancers in a landscape, with all the brilliance, novelty, and gallantry the painter was capable of bringing to the pastoral genre."[47] It is, indeed, a sure-footed work, its *fête galante* theme of fashionable folk and figures from the theatre displaying the hallmarks of Lancret's maturity: a coherent and carefully structured composition, a large canvas, vibrant and lasting color, well-schooled technique, figures

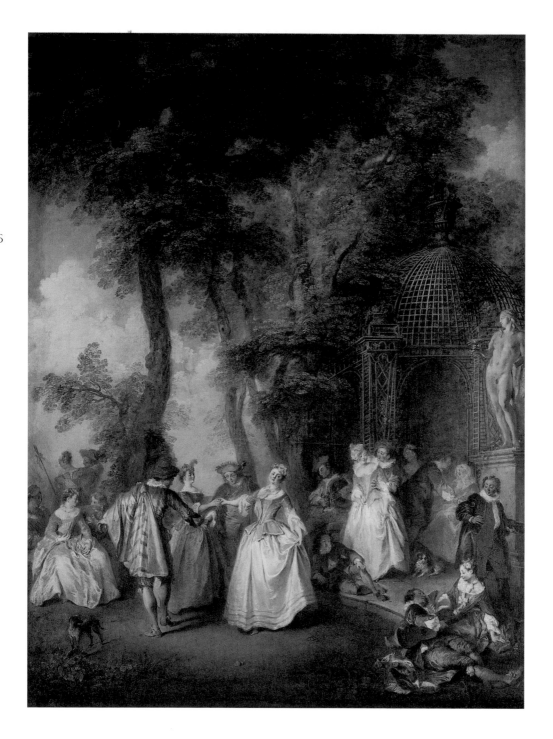

clearly defined and bearing Lancret's trademark wide cheekbones and heavy-lidded eyes, and the establishment of a legible narrative. As his career progresses, his figures will grow into the space and become fewer [see, for example, FIGURE 23], they will move to the foreground, and his narrative will become more emphatic; but the seeds of this independent manner are sown in these works made close to 1720. In the printed accounts of the Expositions, we find the beginning of the public admiration and published acclaim that Lancret will continue to inspire throughout his working life. In the accounts of Lancret's contributions in the *Mercure de France*, we read of his "brilliance, novelty and gallantry" (in 1724) and see his subjects described as having been "treated in the most graceful manner in the world" (in 1722).[48]

In 1725, the duc d'Antin organized a shortened official Salon, lasting only ten days rather than the usual four weeks. It is often referred to as the "pseudo" Salon.[49] Regular Salons did not begin again until 1737. The 1725 showing is chiefly remembered as a key episode in the battle of Jean-François de Troy and François Le Moyne for preeminence in history painting. It was also Lancret's first opportunity to exhibit under the Academy's prestigious aegis. The *Mercure de France* detailed his entries thus:

> An arched painting 6½ feet wide by 5½, representing a Ball in a landscape adorned with architecture. Return from the hunt, 4 feet wide by 3, in which we see various horsemen and ladies in riding dress taking a meal. Women bathing. View of the Saint-Bernard Gate, same size; Dance in a landscape, a small painting; Portrait of M. B [allot] playing a guitar in a landscape: boldly handled easel painting.[50]

Clearly, Lancret took the opportunity to display the full gamut of his abilities. His contemporaries, equally starved for exhibition opportunity, did the same, and a wide range of subject matter was a feature of the entire Salon. Lancret's entries cannot be identified with certainty, but good candidates exist and must give us a close approximation of his contribution. The Dresden *Dance Between Two Fountains* [FIGURE 33],

FIGURE 32
Nicolas Lancret, *Quadrille Before an Arbor (Der Tanz "Le Moulinet")*, circa 1723. Oil on canvas, 130 × 97 cm (51⅛ × 38¼ in.). Stiftung Preußische Schlösser und Gärten Berlin-Brandenburg, Berlin, Schloss Charlottenburg, GKI 4188. Photo: Jörg P. Anders.

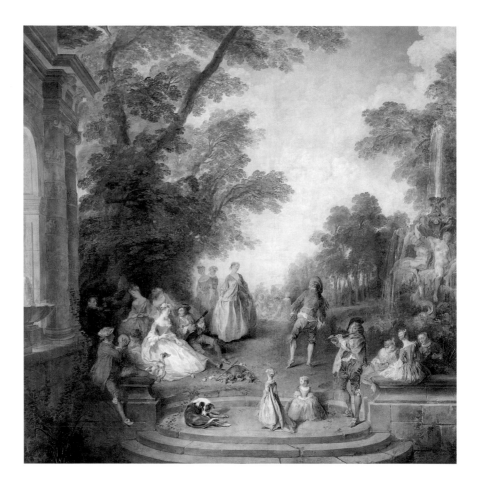

38

Luncheon in the Forest now in Sans Souci, and *Pleasures of the Bath* (Paris, Musée du Louvre) can all be dated to the mid-1720s by their compositions (more populated than later works) and figural proportions (especially the figures' small heads).[51] The Dresden painting has much in common with the Getty *Dance* [FIGURE 1], and it includes a variant of the same fountain. In addition, the portrait of Ballot has recently shown up on the market.[52]

Lancret was now, at thirty-five, a mature, independent artist successfully launched on his career. His fully developed style evinced both ease and individuality as he moved toward a narrative technique characterized by liveliness of color and facial types. He had been

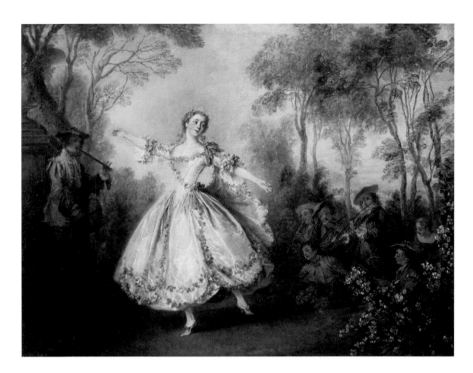

FIGURE 34
Nicolas Lancret, *Mademoiselle de Camargo Dancing*, before 1730. Oil on canvas, 41.7 × 54.5 cm (16 3/8 × 21 1/2 in.). London, Wallace Collection, P393.

patronized by the powerful Louis-Antoine de Pardaillan de Gondrin, duc d'Antin, *Directeur-général des bâtiments et Jardins due Roi, arts, manufactures et académies royales*, in charge of all official art purchases and exhibition.[53] By 1730, he had garnered at least two major decorative commissions from influential patrons, painted an immediately celebrated portrait of a famous ballerina, and begun the production of the ever-popular prints after his work. The two important commissions—one for Abraham Peyrenc de Moras, a wealthy and well-connected financier, and the other for Jean-François Leriget de la Faye, a prominent diplomat, collector, and poet—were for extensive decorative cycles.[54] Such groupings were to form a major part of Lancret's commissioned work, most notably those he did for Louis XV. The Leriget paintings were engraved, and must have assisted the spread of Lancret's popularity.[55]

Lancret's portrait of the dancer Marie-Anne de Cupis de Camargo (1710–1770) placed him firmly in the public spotlight, for she was the most acclaimed ballerina of her time, a worthy successor to

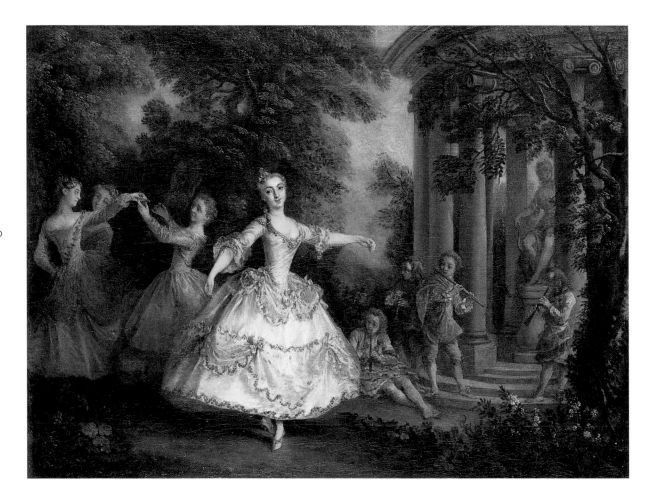

FIGURE 35
Nicolas Lancret, *Portrait of the
Dancer Marie Sallé*, circa 1732.
Oil on canvas, 42 × 54 cm
(16¹/₂ × 21¹/₄ in.). Stiftung
Preußische Schlösser und Gärten
Berlin-Brandenburg, Berlin,
Rheinsburg Palace, GKI 51071.
Photo: Wolfgang Pfauder.

Françoise Prévost at the Opéra [FIGURE 34]. Lancret did at least three versions of the painting,[56] and the print after the portrait by a professional engraver, Laurent Cars (1699–1771), authorized in August of 1730, was so successful that it was immediately counterfeited.[57] Two years later, Lancret would provide *Mademoiselle Camargo* with a pendant: a portrait of Marie Sallé (1707–1756), who was equally celebrated in dance [FIGURE 35].[58] Leriget de la Faye was the first owner of the Mademoiselle Camargo portrait from which the print was made (probably the one now in the Wallace Collection in London), and the Mademoiselle Sallé pendant went quickly to Berlin, which held great

collections of eighteenth-century art in general and of Lancret in particular. The portraits of these two women, together with Lancret's later portrait of the actor Charles-François-Nicolas-Racot de Grandval (1710–1784) and his depictions of actual scenes from plays, represent a new development in the artist's response to theatrical subjects.[59] The works evoke contemporary theater much more directly, are keener indications of Lancret's personal involvement in it, and offer a more sophisticated blend of fact and fantasy than the straightforward commedia dell'arte scenes (such as FIGURE 30).

A survey of the decade 1730–40 presents a panorama of Lancret's success as a painter. His commissions multiplied. In France his work was collected by Jeanne d'Albert de Luynes, comtesse de Verrue (the model for *La Dame de Volupté* by Dumas père); Victor-Amédée, prince de Carignan; Claude-Alexandre de Villeneuve, comte de Vence; Monsieur and Madame Louis-Jean Gaignat; Jean de Jullienne; Antoine de La Roque; Jean Cottin; and Quentin de L'Orangère—in short, by a solid cross-section of the major art patrons of his time.[60] As we know, La Live de Jully owned a reduced replica of one of the works Lancret created for Louis XV. Lancret's paintings were also extremely popular at foreign courts, and were represented in the collections of Count Heinrich von Brühl at Dresden, Clemens Augustus I, Elector of Cologne, Catherine II of Russia, Queen Louisa-Ulrika of Sweden, and especially her brother, King Frederick II of Prussia.[61] His major patron, however, and the source of steady commissions from the mid-1730s until Lancret's death, was Louis XV. Lancret provided not only decorations for the king's apartments at various royal residences—Versailles, Fontainebleau, and La Muette [FIGURE 36]—but also numerous works for the quarters of the queen and of the royal mistresses, as well as gifts for Louis' friends. Perhaps the most memorable commission, and one of the most indicative of the king's personal favor, is *Luncheon with Ham* [FIGURE 24]. This painting—like its pendant *Luncheon with Oysters* by Jean-François de Troy, both now in Chantilly at the Musée Condé—was commissioned in 1735 for the dining room of the *petits cabinets* at Versailles, a maze of small rooms that the king had constructed in the north wing

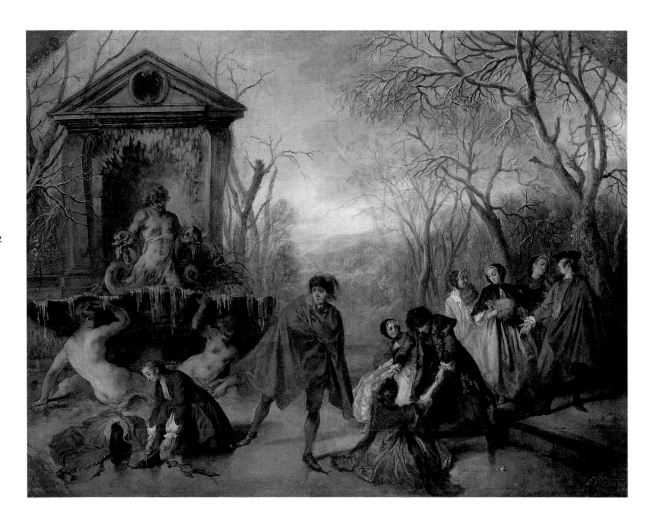

FIGURE 36
Nicolas Lancret, *Winter, from the
Château of La Muette*, circa 1738.
Oil on canvas, 69 × 89 cm
(27 1/2 × 35 in.). Paris, Musée
du Louvre, RF 926. Photo:
Arnaudet.

for his leisure hours.[62] It was a mark of particular favor to be asked to provide so prominent an item in their decoration, and Lancret supplied other works for these private rooms as well.

Also in 1735, Lancret was made *Conseiller* at the Academy. He presented the *Dance Between the Pavilion and the Fountain*, now in the Palace of Charlottenburg, Berlin [FIGURE 37]. This painting is singled out for praise by both Ballot and d'Argenville, and Lancret himself must have thought highly of it, as he based his bid for office entirely on this one submission. It is a lovely example of the subtle chiaroscuro Lancret

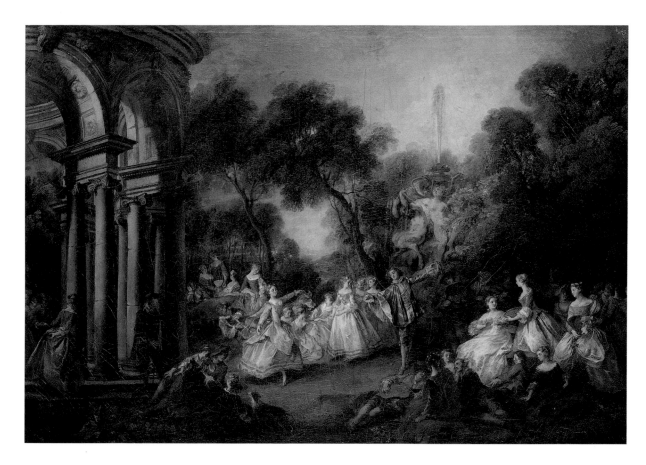

could achieve, of his ability to differentiate the glimmer of light on foliage from that on rosy skin or shining silk.

After the Salon was reestablished in 1737, Lancret exhibited there regularly until his death. His scenes from popular plays and his portrait of Grandval were shown during this period, along with many depictions of children's games. In 1736, he took up the series of scenes from the *Tales of La Fontaine* left unfinished by Jean-Baptiste Pater (1695–1736) at his death. Pater had made eight paintings, and Lancret provided a further twelve on copper [see, for example, FIGURE 2]. All twelve would form part of the famous *Suite Larmessin*, thirty-eight illustrations of the *Tales* engraved by Nicolas de Larmessin between 1737 and 1743.[63] Lancret produced some of his best paintings in the early years of the 1740s,

FIGURE 37
Nicolas Lancret, *Dance Between the Pavilion and the Fountain*, 1733. Oil on canvas, 62 × 88 cm (24³/₈ × 34⁵/₈ in.). Stiftung Preußische Schlösser und Gärten Berlin-Brandenburg, Berlin, Schloss Charlottenburg, GKI 1808. Photo: Jörg P. Anders.

FIGURE 38

Nicolas Lancret, *The Peepshow Man*, 1743. Oil on canvas, 52 × 77.5 cm (20½ × 30½ in.). Stiftung Preußische Schlösser und Gärten, Berlin-Brandenburg, Berlin, Schloss Charlottenburg, GKI 51115. Photo: Wolfgang Pfauder.

before his death in 1743. Two grand paintings from this period, the Stockholm *Fastening the Skate* [FIGURE 27] and the London *A Lady in a Garden Taking Coffee with Some Children* [FIGURE 23] are masterpieces of eighteenth-century art as well as enchanting glimpses of eighteenth-century life.

Lancret's surviving oeuvre is quite large, and all his early biographers speak of his total absorption in his work. Depending on their critical bias, they found this devotion either one of his chief virtues or characteristic of a pedantic and unimaginative outlook. Ballot treats this quality with respect:

Drawing and painting were preoccupations with M. Lancret. He had such a great love of work that he would have found the feast days burdensome had he not felt obliged to fill them attending to the demands of religion, which he always did until the final moment of his life.[64]

Ballot adds that Lancret's hard work set a good example for young students at the Academy, to whom, he says, Lancret was very kind. Parisian art dealer Edme-François Gersaint (1694–1750), too, notes Lancret's good nature, praising "his polite, gentle, compliant, and affable temperament."[65] Printmaker and publisher Pierre-Jean Mariette (1694–1774), however, found little to admire in Lancret's habits or his art, characterizing him as "a rather serious man, one who, going about little in society, busied himself only with his work," though he remained, for all that, "only a practitioner."[66] A tally of the works listed in Wildenstein's catalogue authenticates these accounts of how Lancret spent his days. As Ballot observed, "The story of a life of labor such as Lancret's is all locked up, so to speak, in the quantity of work that remains with us."[67] Wildenstein's 1924 catalogue includes 787 items. Even if that figure is slightly inflated, it is still an enormous production. If Lancret began painting seriously in 1708, at the age of eighteen, he would have had to turn out some twenty works a year to reach just 700.

He finally married, late in life. In 1740, he wed Marie Boursault, who was nearly twenty years his junior. She would outlive him by almost forty years. They had no children, and on his death in 1743, Lancret left everything to her. The catalogue of her sale in 1782 consists mainly of works collected by Lancret himself and is thus a remarkable document of his catholic tastes.[68] He was an impressive connoisseur, and the catalogue reflects his own attributions and scholarly particularity, such as "Lely in the style of Van Dyck."[69]

Lancret died virtually at his easel, on September 14, 1743, apparently of pneumonia. Ballot, always the affectionate friend, says he expired while painting the only work that ever completely pleased him. That painting, or its close variant, is today at Charlottenburg Palace [FIGURE 38].[70]

46

NICOLAS LANCRET WAS A PARISIAN, BORN AND RAISED. FROM ALL accounts, he reveled in his hometown, delighting in its theaters, strolling its streets and gardens, lounging in its cafés, frequenting its Salons. As far as we know, Lancret never left Paris, this earthly paradise. Indeed, although he sought the Prix de Rome, he never won it and never made another attempt to stray, even when he was in funds. Perhaps he never felt the need to leave. Everything a cultivated man of the eighteenth century might want was in Paris as nowhere else at the time. Or at least everyone in Paris seemed to think so, as did nearly everyone in France; Paris was emerging as the cultural capital of Europe, rivaled only by Rome. It was the Paris of Voltaire, the composers Jean-Philippe Rameau and François Couperin, and the playwrights Pierre Carlet de Chamblain de Marivaux and Florent Carton Dancourt. As one scholar points out, "People came from everywhere and visited France and Paris as the center of all that was grand in modern Europe." She goes on to call Paris of this era the "intellectual capital of Europe."[71]

This Paris of Lancret, this center of culture and light, was a fairly recent creation. The last years of Louis XIV, the Sun King, were terrible for France. The early eighteenth century saw a continuation of the calamitous wars that brought France to the brink of bankruptcy. The devastating and drawn-out War of the Spanish Succession, which pitted France and Spain against England, Austria, and the Netherlands, did not end until 1713 (with the shaky Peace of Utrecht). It is estimated that Louis XIV finished his reign (he died in 1715) some four *billion* livres in

debt, a figure proportionately higher than the sum that would eventually help ruin Louis XVI. The expense of engaging in these conflicts was the putative cause of the famous and futile silver melt, when the king melted the silver at Versailles in an attempt to "plug some holes" and show solidarity with his exhausted people. The year 1709 saw the coldest winter in anyone's memory—rivers froze and people starved. To add to the misery of these martial, meteorological, and financial struggles, Louis endured terrible personal tragedy as well. In the space of a few years, he lost his son (in 1711, from smallpox), his grandson and his grandson's wife (within a week of one another, in 1712), and his great-grandson (1714), leaving only the infant son of the duc and duchesse de Bourgogne (the aforementioned grandson and his wife) to inherit the throne. It would be hard to dispute the words of Madame, the mother of the future regent, who remarked in 1709, "Never in my life have I seen such wretched and miserable times." The king increasingly took refuge in the extreme religious fervor of his unofficial wife, the dour Madame de Maintenon, and Versailles became a hidebound, joyless tomb.[72]

The court began to flee. As Katie Scott points out, "Despite Louis XIV's attempts to stay the movements of his courtiers and consolidate their presence around him at or within the vicinity of Versailles the court's grands slipped away to Paris."[73] This exodus helped inspire an amazing building boom, as Scott goes on to describe: "Thus, even before the Grand Monarque had been ceremonially dispatched below ground, hotels were beginning to spring up all over the capital [FIGURE 39]."[74] This exodus of princes of the blood and the nobility was not the only source of the new building, however. A very determined, very rich, and very upwardly mobile class of

47

FIGURE 39
Nicolas Pineau (French, 1684–1754), Cartouche for the *porte-cochère* of the Hôtel de Mazarin, rue de Varenne, circa 1737. Red chalk on paper, 42.3 × 53.4 cm (16 5/8 × 21 in.). Paris, Musée des Arts Decoratifs. Photo: Laurent Sully Jaulmes.

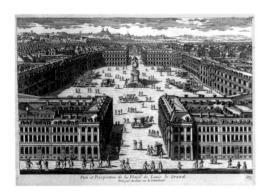

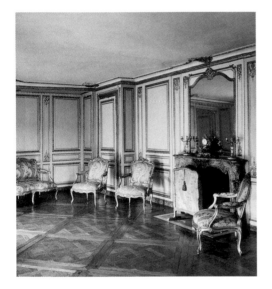

FIGURE 40
Adam Perelle (French,
1638–1695), *View and Perspective of
Place Louis le Grand (Place Vendôme)*.
Engraving. Photo: Bibliothèque
Nationale, Est. Va 234.

FIGURE 41
Dining room in *petits cabinets du
roi*, Versailles, Château de
Versailles. Photo: Jean-Marie
Manai, courtesy Xavier Salmon.

financiers was also committed to building status-
enhancing homes in the middle of the most significant
town in Europe. The two centers of the boom were thus
divided along class lines: "Place Vendôme and the
immediate neighborhoods emerged soon enough as the
center of financier high society to challenge the gilded
enclave the nobility had simultaneously been developing
on the opposite banks of the Seine."[75] This "counterfeit
culture,"[76] to use Katie Scott's apt description, used the
same architects, designers, wood-carvers, and painters
as did their betters and collected the same manner of
art [FIGURE 40].

The building boom coincided with a new desire
for intimacy and comfort in domestic arrangements of
all classes, a desire that was reflected in the interior
architecture, furniture (which Sir Francis Watson once
described as "contrivances of indolence"), and decora-
tion. The small scale, private location, and purposeful
intimacy of the *petits cabinets du roi*, where Lancret's paint-
ings were displayed, is a prime example of this trend
[FIGURE 41].

The art world was embroiled in much of the same
confusion and fluidity—and loss of traditional author-
ity figures—as the political and social realms. Thomas
Crow, describing the early eighteenth century as a time
of destabilization of established cultural norms and
practice, has catalogued the sorry state of the Academy,
the official voice of French art, at this time.[77] Its exhibi-
tions had dwindled in frequency and size, with only one
in 1699, one in 1704, and the abbreviated one in 1725.
They would not function on the intended yearly basis
until 1737. Their theoretical dialogue was equally
debased and intermittent. The heroic mode of art that
was their highest aim was losing ground daily, falling to

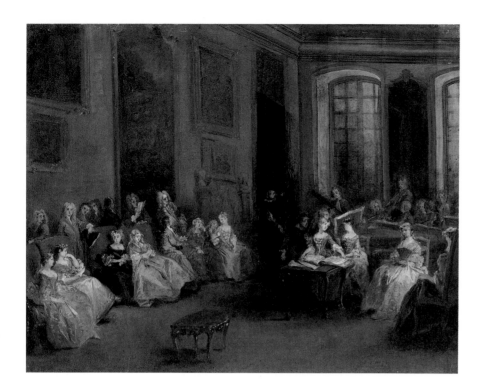

49

a new Parisian taste for gallantry. Into this yawning gap of cultural discourse would step the informed intellectual *amateur*. One such figure stands out: Pierre Crozat, who established in his town house on the rue Richelieu (in the neighborhood of Place Vendôme, of course) a weekly meeting of artists, musicians, politicians, writers, thinkers, and other *amateurs* that included Watteau, Lancret, the duc d'Orléans himself, and so forth. This gathering became, as Crow describes, "a kind of shadow Academy, sustained by private initiative and enthusiasm, but carrying on many of the actual Academy's public responsibilities on quite a significant scale"[78] [FIGURE 42].

The situation was ripe for a greater variety of visual art to emerge, and so it did. The market for the heroic declined. The market for Netherlandish art and genre art rose. Speaking of the important role the print would play in disseminating genre imagery, Anne L. Schroder says, "The increased interest in genre painting and popular imagery at

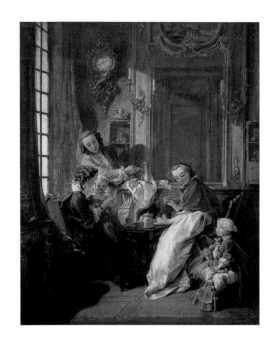

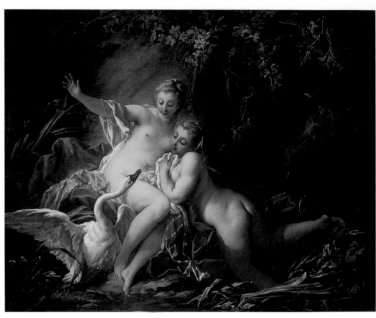

FIGURE 43
François Boucher (French,
1703–1770), *The Luncheon*, 1739.
Oil on canvas, 81 × 65 cm
(31⁷/₈ × 25⁵/₈ in.). Paris,
Musée du Louvre, RF 926.
Photo: Arnaudet.

FIGURE 44
François Boucher, *Leda and the
Swan*, 1742. Oil on canvas,
59.7 × 74.3 cm (23¹/₂ ×
29¹/₄ in.). Beverly Hills, collection
of Lynda and Stewart Resnick.

the beginning of the eighteenth century reflected a broadening of official taste and the reassertion of private patronage, reversing the previous trend."[79]

Such an environment—with its deflated Academic influence; increasingly less relevant hierarchy of genres; cross-pollination of cultural norms; aristocrats seeking gallantry; financiers seeking status, stimulation, and amusement; and a middle class who loved to shop—favored a nimble artist, one not thoughtlessly bound to old traditions of genre and placement, flexible enough to attract both old-guard and avant-garde interest, and broad-minded enough to seek popular acclaim. This qualification is not to debase the role of talent among the artists of the early eighteenth century. However, to prosper in this mutable environment, an artist needed something more—to be an able opportunist. Such an

artist was Nicolas Lancret.[80] Together with him must be mentioned Boucher [FIGURES 43, 44], Charles-Joseph Natoire (1700–1777), Oudry, Lemoyne, and de Troy [FIGURES 45, 46], all of whom made their services available and accessible to as broad a population as possible.

FIGURE 45
Jean-François de Troy (French, 1679–1735), *Before the Ball*, 1735. Oil on canvas, 82.2 × 64.8 cm (32 3/8 × 25 9/16 in.). Los Angeles, J. Paul Getty Museum, 84.PA.668.

FIGURE 46
Jean-François de Troy, *Diana and Her Nymphs Bathing*, circa 1722–24. Oil on canvas, 74.3 × 92 cm (29 1/4 × 36 1/8 in.). Los Angeles, J. Paul Getty Museum, 84.PA.44.

Les fontaines sont, après les plantes, le principal ornement des Jardins....
On les place dans les plus beaux endroits, et les plus en vue de tous les côtes.[81]

THERE IS A GRAND WORKING FOUNTAIN IN LANCRET'S SCENE; TOO
big to be contained within the frame, the wall fountain angles inward
from the right corner and provides depth to the stage on which the fig-
ures play; it gives them their "room," if you will. However, this fountain
is not included in the painting only to define the stage and provide a
sense of luxury. It is a borrowing—the use of an actual built structure—
but one with a particular resonance and importance for the artists of the
fête galante. The astute visitor to Paris will recognize it, for it is still there:
the Fountain of Maria de' Medici (more properly called the "Grotte du
Luxembourg") in the gardens of her Luxembourg Palace [FIGURE 47].
This palace and its gardens have served as a regal oasis in the dense urban
maze of Left Bank streets since their creation in the seventeenth century.
The architecture of the palace [FIGURE 48], with its distinctive rustica-
tion and banding, is a familiar image. It was built in 1615 by Salomon de
Brosse (1571–1624/26) for Maria de' Medici, the widow of Henry IV
and regent of France during the minority of Louis XIII. The gardens
that surrounded the palace were begun before construction of the build-
ing, the first trees planted and the aqueduct put in before the first stone
of the palace was laid. The garden as it was then, and as it was during
Lancret's lifetime, was bigger than it is now.

The grotto[82] was planned as the terminus of a view down a long

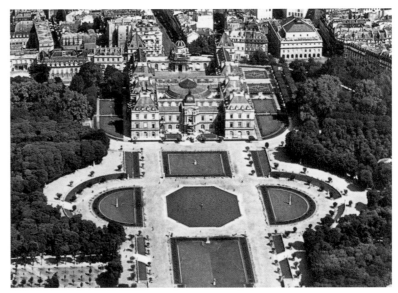

allée of trees to the east of the palace, part of a scheme to shield the palace from the houses on rue de l'Enfer (now Boulevard St. Michel). Built sometime between 1623 and 1630,[83] it was near the orangerie, and featured flanking walls with false arches that repeated the architecture of the orangerie. The side walls were gone by 1855, and the rest of the fountain was moved toward the palace in 1862 to make room for a road. The original design, as one can see in the 1660 engraving by Jean Marot now in the British Museum [FIGURE 49], included the arms of Maria de' Medici on the centerpiece, surmounted by *pots à feu*. The reclining marine divinities, the Seine and the Rhône, were provided by Pierre Byard (or Biard). The fountain itself has undergone considerable alteration since the seventeenth century. The *pots à feu* were gone by 1752 (evidently by accident) and the arms by 1802 (removed by design, replaced much later). The standing sculptures one sees today in all three niches were added in the nineteenth century, along with the long basin of water and other picturesque elements.

Lancret's depiction of the fountain is quite faithful to its eighteenth-century appearance; the view here does not go far enough

FIGURE 47
The Fountain of Maria de' Medici (*Grotte du Luxembourg*), as it appears today in Paris at the Luxembourg Gardens and Palace. Photo: Mark Leonard.

FIGURE 48
Aerial view of the Luxembourg Gardens and Palace, Paris, from Lorenzo Bocchi, *Qui Parigi* (Milan, 1968), p. 17, pl. 1 (detail). Photo: Alain Perceval.

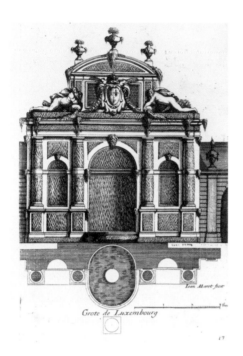

Grote de Luxembourg

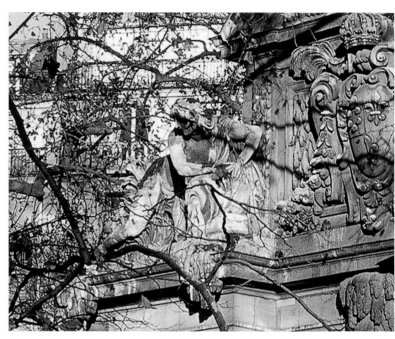

FIGURE 49
Jean Marot (French, 1619–1679),
Grote de Luxembourg, 1660.
Engraving. London, British
Museum, 1937-9-15-442(214).

FIGURE 50
Detail of the female figure on the
Fountain of Marie de' Medici in
Paris at the Luxembourg Gardens
and Palace. Photo: Mark
Leonard.

to include the pots, but the marine divinity is there in much the same pose [FIGURE 50, compare to FIGURE 10],[85] as well as the banded Tuscan columns with *congélation*, and the empty niches. Although the fountain is truncated, it does not appear that the arms are there in any way. Perhaps including such a complicated design element seemed too busy and distracting for the upper corner, and perhaps Lancret did not want to refer so obviously to the actual location. He made one important change to the fountain "workings." The central niche in Marot's engraving shows a low basin of water and a raised socle for sculpture. Lancret replaced that design with a trilobate basin on a stand, and a jet of water spurting upward. It enlivens the fountain and makes the water more of an element in the composition. Instead of laying flat in a basin, the water catches light and moves (one might even say dances). There is a similar fountain in the *Dance Between Two Fountains* [see FIGURE 33], but it is a variant of the Medici design, and Lancret made even more alterations. There, the columns have Ionic capitals and much more banding, there is light coming in from behind (not possible with the wall design of the

FIGURE 51
Detail of infrared reflectogram
showing the architectural
balustrade, later painted over
by the artist. Photo: Tiarna
Doherty.

Medici fountain), and there is a low fluted basin with a jet of water. Lancret made no attempt in either painting to reproduce the site, refer to the palace or the orangerie, or include the allée of trees. The fountain has been relocated to a garden of Lancret's design.

Lancret's choice of this fountain must be understood as a very deliberate one. Infrared reflectography has revealed [FIGURE 51] that the Getty painting once contained, instead of the fountain, a balustrade that extended from the right side all the way to the woman with the straw hat, at a height roughly six inches above her head.[86] This balustrade, or one like it, appears in other paintings by Lancret, for example *The Ball* in Berlin [FIGURE 52], where it supports musicians. In the Getty painting, Lancret painted over the balustrade with trees and anchored the right side with the fountain instead, a laborious choice.

Why this fountain? It has the virtue of being instantly recognizable, which locates this merry company in a Paris garden, with their clothes telling us when they are there. But it has another significance as well. In the early eighteenth century, this palace, with its art and

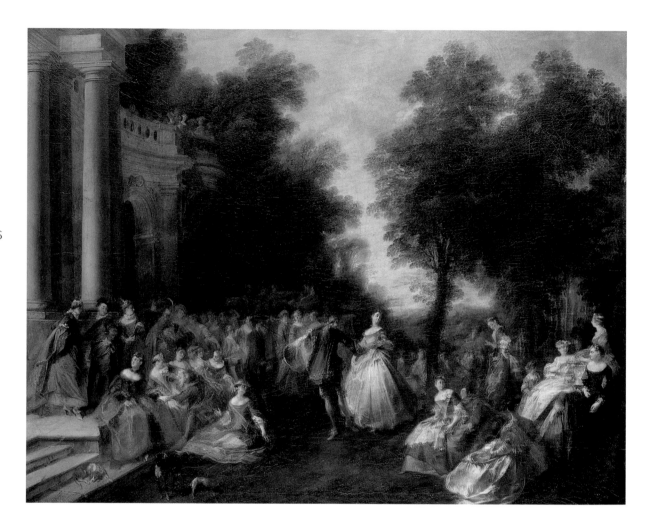

56

FIGURE 52
Nicolas Lancret, *The Ball*, 1720s.
Oil on canvas, 76 × 93 cm
(29⁷⁄₈ × 36⁵⁄₈ in.). Stiftung
Preußische Schlösser und
Gärten Berlin-Brandenburg,
Berlin, Schloss Charlottenburg,
GKI 4189.

gardens, was like a second Academy to the artists of the *fête galante*, bringing together in one place many of the elements essential to the development of the novel genre. The headmaster, so to speak, of this second Academy was Claude III Audran (1658–1734), a prolific decorative painter, ordinary painter to the king, and *concierge* (or curator) of the Luxembourg from 1704, with all the access that implied for this still-royal residence. Audran was well acquainted with Watteau, who apprenticed with him on leaving Claude Gillot. Audran, as is well known, let Watteau wander freely among the paintings and gardens. Nicolas Lancret

also knew Audran and collaborated with him on at least one important commission (and probably more), the Hôtel Peyrenc de Moras, 23, Place Vendôme.[87]

Exactly what about the Luxembourg makes one suggest its special status among sites? Aside from its accessibility, what makes the palace more significant than, say, Versailles, Chantilly, or Fontainebleau, all royal palaces and estates in reasonable proximity to Paris? First of all, one must listen to what the comte de Caylus, in his 1748 life of Watteau, had to say about the gardens and Watteau's preference for them:

> It was to the Luxembourg that he would go to draw the trees of its fine gardens, which presented countless vistas since they were *less strictly laid out and less manicured* [my emphasis] than those of the other royal residences. These vistas could only be enjoyed by the true landscape painter, one who is able to find variety in a single place either from the innumerable viewpoints he adopts, or from the conjunction of distant views, or, finally, from the light shed by the morning and evening sun, which is capable of transforming the same place.[88]

In other words, the Luxembourg Gardens presented in nature (according to the comte de Caylus) the same mix of elements that makes up the landscape of the *fête galante*: graceful garden structures embedded in a naturalistic, even slightly irregular, landscape! Other available gardens did not have this combination of features. The parterres and rigidly formal geometry of much royal garden design would not have been suitable to the cadence of the *fête galante*, with the curving lines of its compositions and the graceful contours of its participants. The beguiling blend of the artificial and the natural at the Luxembourg assisted artists in their creation of "a fusion of the Garden of Love theme with the pastoral tradition inherited from Titian and Veronese"[89] that is the *fête galante* landscape. The love garden imagery provided the staffage of fountains and statues and the cast of courting characters, and the pastoral elements emphasized untended nature. And Watteau's advice to the emerging Nicolas Lancret? "Draw landscapes in the environs of Paris."[90]

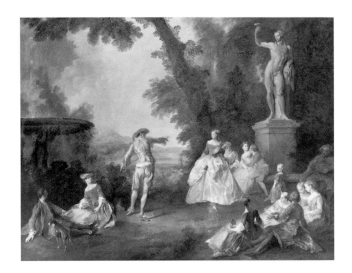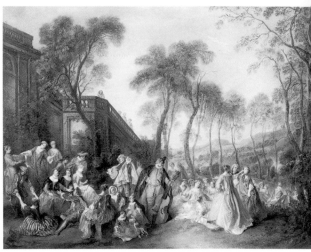

FIGURE 53
Nicolas Lancret, *The Dance
in the Park*, probably 1730s.
Oil on canvas, 117 × 144.7 cm
(44 × 57 in.). Toledo, Museum
of Art, purchased with funds
from the Libbey Endowment,
Gift of Edward Drummond
Libbey, 54.17.

FIGURE 54
Nicolas Lancret, *Musical Party
with a Staircase*, circa 1725.
Oil on canvas, 96 × 138 cm
(37¹³⁄₁₆ × 54⁵⁄₁₆ in.). Private
collection, location unknown.

It is not hard to picture Lancret strolling down the same garden path
that Watteau had walked before him.

The second reason the Luxembourg was a crucial meeting place
for the artists of the *fête galante* was the art on its walls. The palace housed
the monumental cycle of the *Life of Maria de' Medici*, painted by Peter Paul
Rubens between 1622 and 1625, now in the Louvre. Rubens's impor-
tance to the artists of the *fête galante* has often been noted. The warmth
and sensuality of his color, the grace of his figures, the fluidity of his
paint, even the three-color crayon drawing style were all greatly influen-
tial. Here in the Medici palace an artist could sit at the feet of twelve
enormous canvases filled with that style.

Lancret's fountain, then, places us in Paris and in a cultivated gar-
den but also perhaps pays homage to a location that mattered a great deal
in the creation of his work.

The garden setting of the Getty Lancret is characteristic of
Lancret's oeuvre in particular and his genre in general: the *fête galante*
artist overwhelmingly preferred outdoor to indoor settings[91] and desig-
nated them as being cultivated with the presence of stairs, fountains,
pavilions, statues, and all manner of garden structure. Such settings are
ubiquitous in the work of Watteau, Pater, Lancret, and other, lesser,

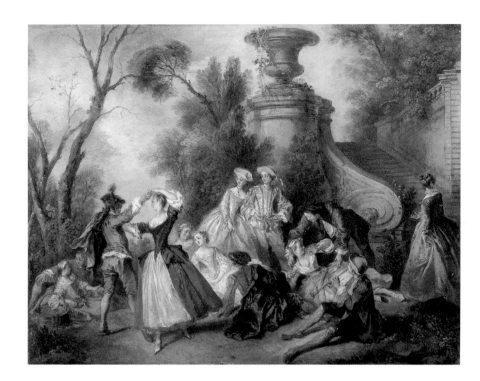

59

lights of the genre. Lancret, however, was not content merely to move this model forward in time, unchanged. In his hands, these garden embellishments become grand and solid signifiers of luxurious space, with a three-dimensional presence that sets them quite apart from their predecessors and contemporaries.

These structures and sculptures are everywhere present in Lancret's art. There are statues: A majestic Bacchus towers over the dancers in the painting in the Toledo Museum of Art [FIGURE 53], balanced on the other side by a great spurting fountain, its basin held aloft by marine figures. A similar Bacchus, backed by a large trellised garden pavilion, stands watch over the Charlottenburg *Quadrille Before an Arbor* [see FIGURE 32]. The pendant to that scene houses its dancers in a glamorous oval garden room, strewn with lively sculpture and topped by a painted ceiling. In Charlottenburg, too, one finds *Dance Before the Horses of the Sun* [see FIGURE 56], with its huge and glowing sculpted group. In

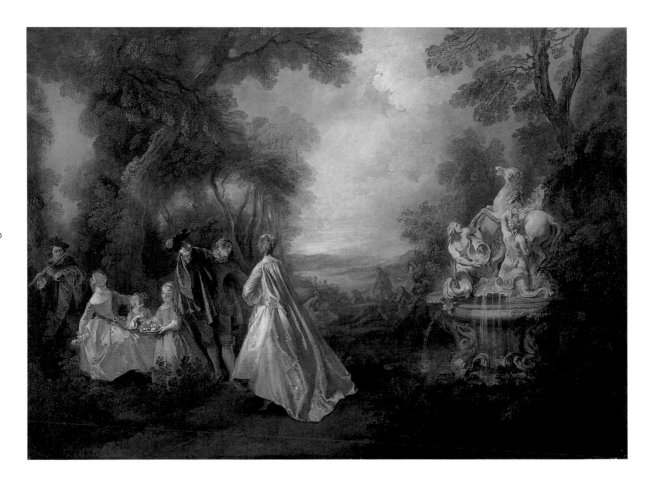

FIGURE 56
Nicolas Lancret, *Dance Before
the Horses of the Sun*, circa 1725.
Oil on canvas, 76 × 107 cm
(29⁷/₈ × 42¹/₈ in.). Berlin,
Stiftung Preußische Schlösser
und Gärten Berlin-Brandenburg,
Schloss Charlottenburg.

a painting in the Palazzo Barberini in Rome, one finds a truly extraordinary scene of elegant figures, including one in Persian dress, admiring a huge statue of a man bending a bow [see FIGURE 59].

There are fountains: The scene of *Winter* [see FIGURE 36] for a set of the Seasons, painted around 1758 for the king's hunting lodge of La Muette, is played out in front of a fabulous frozen fountain composed of a Triton, nymphs, a shell basin, and a grotto-like niche. The skaters are imagined skating on the fountain's own pond. This same fiction is portrayed in Lancret's lovely late *Fastening the Skate* [see FIGURE 27], bought in 1741 for the Queen of Sweden, and still in Stockholm. A similar fountain decorates the landscape in the *Menuet* in Karlsruhe.[92] There

is, of course, the Getty painting's own grand fountain [see FIGURE 1] and its sibling in Dresden [see FIGURE 33]. The Dresden painting includes a big basin fountain on the other side.

And the stairs in Lancret's paintings! Their abundance and variety are remarkable. There are huge terraced behemoths such as the one in the *Musical Party with a Staircase* [FIGURE 54] or *The Ball* in Germany [see FIGURE 52], similar in design to the terraced stairs in certain of the grand gardens of the Île de France, such as those for Château Neuf of Saint-Germain-en-Laye or at the hunting lodge at Meudon. There are graceful rococo curving stairs such as the one in the Wallace Collection's *Dance in the Park* [FIGURE 55], *Earth* in Madrid (Museo de Arte Thyssen-Bornemisza), or Potsdam's *Blind-Man's Buff* in the small gallery in Sans Souci. Stairs are everywhere found, establishing their garden spaces and framing and enhancing the figures.

From whence do they come, these terrific creations? Are they the product of Lancret's own fertile imagination, or is there another source? The Getty painting gives us an important clue. A search for the origins of Lancret's structures reveals something wonderful, but not surprising: a great number of Lancret's most elaborate structural and sculptural elements, such as that in the Getty work, are based on creations by other artists, whether realized or only designed. Judging by the frequency with which they occur and the important consequences they maintain within his paintings, these derivatory tributes were assuredly one of Lancret's favorite devices. Lancret's painted versions of real sculptures and other artists' designs have a prominence and a glow that truly set them apart. It should not surprise us, perhaps, that this artist—his imagery so

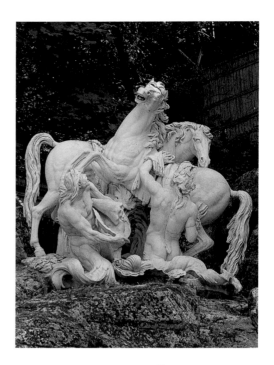

FIGURE 57
Balthasar Marsy (French, 1628–1674) and Gaspard Marsy (French, 1624–1681), *The Horses of the Sun*, 1664–66. Marble. Versailles, Château de Versailles, Apollo Grotto. Photo: G. Blot.

61

FIGURE 58

Hubert Robert, *The Bosquet des
Bains d'Apollon in 1774–77*, 1777.
Oil on canvas, 124 × 191 cm
(48⅞ × 75¼ in.). Musée
National du Château de
Versailles. Photo: Jean-Marie
Manai, courtesy of Xavier
Salmon.

drenched in the visual detail of his time—would prefer to draw his
architectural and sculptural constructs from the same tangible well.

Let us take, for example, the *Dance Before the Horses of the Sun* in
Charlottenburg [FIGURE 56]. Lancret's sculpted group is based on *The
Horses of the Sun* at Versailles. This sculpture, by Gaspard Marsy
(1624–1681) and Balthasar Marsy (1628–1674), formed part of the
group designed for the Grotte de Thétys at Versailles[93] [FIGURE 57]. It
was one of the side sculptures flanking the famous *Apollo Tended by Nymphs*,
by François Girardon. *The Horses of Apollo* on the other side was by Gilles
Guérin (1606–1678). It was a very well-known ensemble, engraved sev-
eral times.[94] It was created between about 1664 and about 1674 and
intended to evoke the well-earned rest of the Sun God after a long day's
work. In 1682 the grotto was demolished.[95] The sculptures were moved
to the lower end of the Bosquet du Marais and placed under gilded
lead baldachins. This was their location when Lancret saw them. Then,
in 1778, the entire ensemble was moved to a picturesque landscape
designed by Hubert Robert. Lancret chose the most active and "rococo"
of the three groups, the one with the most curving silhouette. He raised
the group and created a working fountain. As was his custom, Lancret

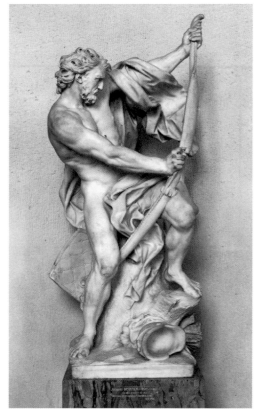

placed the sculpture in his own parkland but retained the original evocation of leisure and rest. Hubert Robert takes a very different approach to his inclusion of the same statue in *The Bosquet des Bains d'Apollon in 1774–77* [FIGURE 58], carefully documenting the installation of his new location for the sculptures.

A particularly noteworthy instance of Lancret's borrowings can be found in Rome, in the Galleria Nazionale d'Arte Antica, Palazzo Barberini. In his painting *The Persian and the Statue* [FIGURE 59], Lancret depicted a sculpture by Jacques Bousseau of a soldier bending his bow, preparing to shoot arrows at Saint Sebastian, which is now in the Louvre [FIGURE 60]. Bousseau presented the large marble to the Academy as his reception piece on November 29, 1715. Lancret's work is especially interesting and fun not only for its obvious virtue as a charming

FIGURE 59
Nicolas Lancret, *The Persian and the Statue*, circa 1728. Oil on canvas, 46 × 38 cm (18 1/8 × 15 in.). Rome, Galleria Nazionale, Palazzo Barberini, neg. no. 186 275.

FIGURE 60
Jacques Bousseau (French 1671–1740), *Soldier Bending His Bow*, before 1715. Marble. Paris, Musée du Louvre, MR 1766.

composition but also because the painting was seen and admired by another eighteenth-century sculptor, Coustou l'aîné. He wrote of his admiration for the painting in 1736, in *Éloge d'une statue de marbre, tableau peint par Lancret*, which was then printed in Ballot's biography of Lancret. In this testament, Coustou describes the circumstances of Lancret's achievement:

> The sculptor gave the painter a model of this figure, as large as the marble; and the painter, to show his gratitude, and how much he valued the gift, sent him this painting. He had painted the statue with precision and placed it in a grove less decorated by the beauties of art than charming by its natural grace and situated under a gentle and serene sky."

Coustou describes the painting in exhaustive detail, finishing with his reasons for admiring it so much:

> The distribution of light, the lively and nimble air of the French as opposed to the attitude of the Persian, the verisimilitude and variety of the fabrics, the witty turn of the figures and the lightness of touch make this a painting interesting to all; but it will be most interesting to you who seek compositions of intelligence.[96]

The two-dimensional creations of designers and painters were as important to Lancret as three-dimensional sculpture. Martin Eidelberg was the first to document Lancret's frequent adoption of fountain designs by Gilles-Marie Oppenort (1672–1742), one of the most important designers of the eighteenth century and an acquaintance of Watteau.[97] Indeed, the source of one of Lancret's most successful fountains, which he used more than once as background for his paintings, was a drawing by Oppenort that had belonged to Watteau, although Eidelberg points out that Lancret probably did not see it in Watteau's collection. The work was part of a group of red chalk drawings that went from Watteau's collection to that of the Abbé Haranger, at which point Lancret surely saw them, and thence to Sweden in 1735 with the Swedish architect Carl Johan Cronstedt (1709–1779). The group is now in the

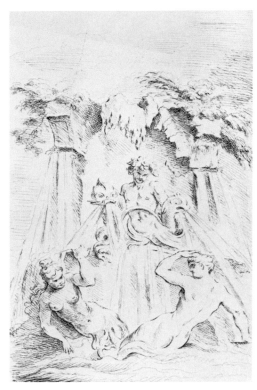

Nationalmuseum in Stockholm. The fountain that appears in *Dance Between the Pavilion and the Fountain* [see FIGURE 37] and *Dance Between Two Fountains* [see FIGURE 33] is Oppenort's *Fountain with a Satyr and a Female Nude* [FIGURE 61]. The Dresden painting places a variant of the Medici fountain on the other side, seen in profile with light coming through. Eidelberg cites Oppenort as the source for other Lancret fountains, for example the extraordinary Triton fountain in *Winter* [see FIGURE 36], which is based on an Oppenort design now known only from the engraving made after it by G. Huquier and published in his *Nouveau Livre des Fontaines* [FIGURE 62].

Another pictorial source for Lancret's architectural elements is the work of Jacques de Lajoüe (1686–1761).[98] The influence of Lancret and Watteau on Lajoüe's figure style is often noted, but the impact of Lajoüe on Lancret's background structures has gone largely unre-

FIGURE 61
Gilles-Marie Oppenort (French, 1674–1742), *Fountain with a Satyr and a Female Nude*, before 1715. Red chalk on paper, 28.1 × 19.8 cm (11 × 7 3/4 in.). Stockholm, Nationalmuseum.

FIGURE 62
G. Huquier after Gilles-Marie Oppenort, *Fountain with Triton and Nymphs*, engraving. Photo taken from *Burlington Magazine*, vol. 110, no. 785 (August 1, 1968), p. 453, no. 44.

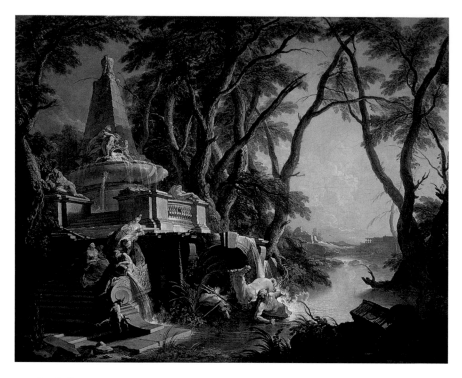

FIGURE 63

Jacques de Lajoüe (French,
1687–1761), *The River (Paysage
Composé au Neptune Mutilé)*,
circa 1736–37. Oil on canvas,
81.5 × 101.5 cm (32 1/8 × 40 in.),
Paris, Musée du Louvre. Photo:
Jean Schormans.

marked. Lajoüe was *agréé* in 1721 as a painter of architectural landscapes; he is best known for his elaborate rocaille architectural fantasies, which prompted the architectural theorist Jacques-François Blondel to designate him one of the "trois premiers inventeurs du genre pittoresque"; the other two were Nicolas Pineau (1684–1754) and Juste-Aurèle Meissonier (1675–1750).[99] It was Lajoüe who incorporated this style into painting, as one can see in the 1734 overdoors for the Hôtel Bonnier de la Mosson. One notes, on looking over Lajoüe's oeuvre, a fondness for grand curving garden stairways, often decorated with reclining gods and nymphs, cascading urns, and huge volutes. A fine example is *The River* [FIGURE 63]. It is very likely that Lancret's repeated incorporation of a curving staircase in the backgrounds of his own paintings, such as that in the Wallace Collection's *Dance in the Park* [FIGURE 55], was directly inspired by the work of Lajoüe.

There is an interesting precedent for the use of a real site, but evidently only one, in the work of Watteau, Lancret's great predecessor

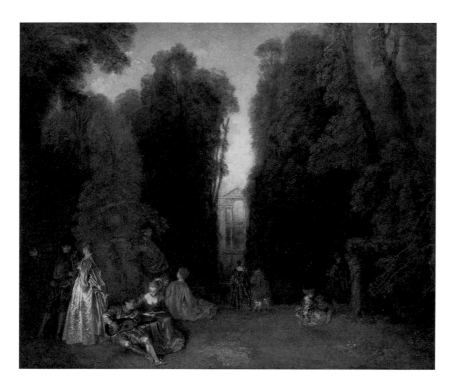

FIGURE 64
Jean-Antoine Watteau, *La Perspective (View Through the Trees in the Park of Pierre Crozat)*, circa 1715. Oil on canvas, 46.7 × 55.3 cm (18 3/8 × 21 3/4 in.). Boston, Museum of Fine Arts, Maria Antoinette Evans Fund, 23.573.

67

in the creation of the *fête galante*, and the differences between their treatments are very illuminating. Watteau's painting *La Perspective*, now in the collection of the Museum of Fine Arts, Boston [FIGURE 64], depicts in the background an actual site, Crozat's Château de Montmorency, north of Paris. Watteau, intriguingly, makes no attempt to ground the scene or its spectators in contemporary life by using this recognizable building. Quite the contrary, in fact. He employs the site in such a distinctive way that, as Alan Wintermute points out, "even Crozat's garden could become the island of Cythera, and his house, an enchanted palace."[100] As Wintermute further explains, it is Watteau's understanding and appreciation of observed and real nature that lends conviction and allure to his fantasy lands.[101]

Lancret achieves something entirely different with his use of real sites, real sculpture, and contemporary design, and with his enhancement of the structures within his landscapes. Far from using these accoutrements to assist the creation of a dream world, Lancret is subtly

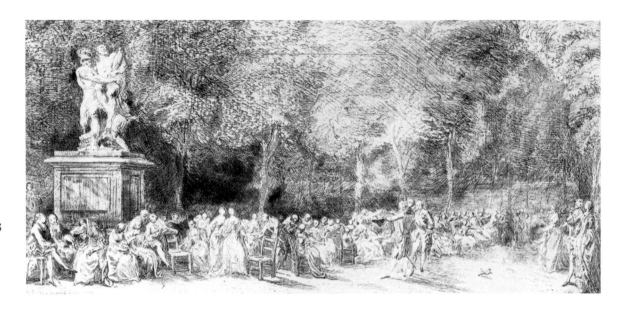

68

enhancing the inextricable link of his scenes to the real world, the contemporary world of Paris, much as the fashionable costumes do. Lancret's garden structures are lively co-inhabitants of the scenes they share with human figures. He does everything possible to elevate their standing within his scenes, to raise them from the status of mere props — as seen in the structures' outsize scale, the lively energy of their contours, and their glowing grisaille or *brunaille* tones [FIGURE 59]. His landscapes and their staffage are achieved with a detailed naturalism and sense of solidity that set them far apart from the gardens of Watteau (even a garden actually located, as the one in *La Perspective*, in the Île de France). If Watteau enchants us by his transcendence of time and the real, Lancret charms us with his fidelity to it.

Lancret paid homage to these works of art and gave them another life inside his fictional realm. He made no attempt to replicate actual settings, only to celebrate the objects themselves. This is, of course, entirely consistent with his flair for introducing contemporary and palpable detail into his art, without ever descending to dry, literal reproduction. In these creations, he stands as a bridge in the development of French urban landscapes, between the fantasy parkland of Watteau and the ebullient documentaries of Gabriel de Saint-Aubin [FIGURE 65].

THE DANCE AND THE DANCERS

Ma commère, quand je danse,
Mon cotillon, va-t-il bien?[102]

LANCRET'S *DANCE BEFORE A FOUNTAIN* IS A CLASSIC EXAMPLE OF the *fête galante*. In their garden world, his young and fashionable characters play out the only one of life's dramas that really matters: the drama of love. Love is the dominating theme of most *fêtes galantes*, and it has center stage here. This love, this evolution of relationships, how is it shown? In the dance, of course, which, then as now, distills the essence of courtship. In many ways, the dance also distills the essence of the *fête galante*—the affluent participants, the noble bodies, the ritual of courtship, the importance of touch and movement, a leisure activity that is neither sloppy nor unformed. That the main characters are engaged in a dance comes as no surprise to anyone familiar with Lancret's work in particular, and with the genre in general. This pastime is a constant feature of Watteau's work as well, and of that of his close follower and student, Jean-Baptiste Pater.

Dance was, as it is today, a feature of parties and balls, and a fixture at court. The dances described in the paintings of the *fête galante* are based, as one can easily discern from their appearance, on real dances. Both the observation of professional dancing and the participation in social dancing had reached new and broad levels of popularity in the opening decades of the eighteenth century. Instrumental in this new-found popularity was the emergence of the *contredanse* and its close fellow

(or simply another *contredanse*, depending on your source), the cotillon.[103] The *contredanse* and cotillon were simple of step and easy to learn, much more fun to do than to watch, and encouraged collective participation. They stood in marked contrast to the dance of the previous age, *la danse noble*, which was designed for display and observation. As Sarah R. Cohen observes: "By all accounts, the contredanse was emerging as the dance form of choice in elite assemblies both within and outside the court, and by the middle of the 1710s, it would spread more widely in Paris."[104]

Assisting both the popularity and the dissemination of contemporary dance was Raoul-Auger Feuillet (circa 1675–circa 1730). Feuillet adapted for publication a form of dance notation created by Pierre Beauchamp, a seventeenth-century ballet master at the Ópera. Beginning in 1702, Feuillet set out to publish annual collections of social dances, accompanied by descriptions and engravings demonstrating the steps in notation. These publications came out nearly continuously through 1725 and purported to contain the newest and most fashionable dances. Feuillet's stated purpose was to make social dancing and his notation available to the widest possible audience. As Cohen points out, "The audience for the dance and its notation . . . presumably included members of the bourgeoisie and the new nobility with the leisure and ambition to appropriate aristocratic dancing for themselves."[105] One can imagine that the artists of the *fête galante* waited eagerly for each new edition, there to find detailed the most up-to-date dances, coupled with a visual description in the form of notation. This would be especially true for an artist such as Nicolas Lancret, as one realizes on examining his passions and hobbies, as well as his art.

Lancret had a passion for theater and performance in all its forms, from the marionettes and Théatre de la Foire, to the Italian Comedy of the commedia dell'arte (which had reopened in 1716) and the Opéra. He frequented them all. Ballot tells us, "This was the only vice attributed to M. Lancret."[106] Perhaps inspired, and certainly encouraged, by his associations with fellow theater-lovers Gillot and Watteau, Lancret's involvement with the stage colored his life as well as his art. Eventually

he would "marry into" the theater when, late in life, he wed Marie Boursault, whose grandfather wrote the stage comedies *Aesop in the City* and *Aesop at the Court*. The direct impact of the theater on Lancret's art is not hard to discern. As we have seen, he painted portraits of theater figures and scenes from plays and peopled his *fêtes* with characters from the commedia dell'arte. Though he never, as far as we know, created set or costume designs, two full renditions of opera scenes are possibly attributable to him—one painted on the inside of a harpsichord lid—

FIGURE 66
Nicolas Lancret, *The Dance Around the Tree*, circa 1747–50. Oil on panel, 43 × 53 cm (16⅞ × 20⅞ in.). Dresden, Gemäldegalerie Alte Meister Staatliche Kunstsammlungen, 786. Photo: Elke Estel/ Hans-Peter Klut.

and he provided two charming frontispieces for books of harpsichord works.[107] He was, therefore, exactly the sort of man likely to be familiar with new dances and to be interested in Feuillet's volumes.

Lancret's work provides us with numerous dances, but these are mostly duets, like the ones performed in *Autumn* [FIGURE 5] or *Dance Between Two Fountains* [FIGURE 33], and the occasional circle dance or ronde [FIGURE 66]. A foursome dance is rare in Lancret's work. I know of only one other example, the Getty painting's sibling variant in Charlottenburg, the *Quadrille Before an Arbor* [FIGURE 32]. If rare in Lancret, it is unknown for the other artists of the *fête galante* (as far as I know). The rarity of this dance in Lancret's art is paralleled in the actual recorded dances of the period, where foursomes are scarce. Meredith Little and Carol Marsh exhaustively inventoried contemporary sources, descriptions, choreographers' notebooks and publications, and dance notation to compile and describe more than two hundred dances of the period, as complete a list as they could document.[108] The vast majority of the collected dances are duets; a few are for a single dancer; but only ten involve four dancers, two men and two women. The names vary from the charming *La Blonde et La Brune* and *Allemande à la Dauphine* to *Le Cotillon* and *Le Passepied à quatre*. They are, from this admittedly limited selection, most often called *Le Menuet à quatre*.

Lancret was no choreographer. He was, however, a keen observer of eighteenth-century life and culture, of those contemporary moments that could be realized to great effect in paint, that could stand in for an age, an emotion. Such a specific dance step as this *moulinet*, one so carefully selected and described, and one so rare in art and life, must have a source, an actual dance step that could have been observed by Lancret.

And so it does.[109] Lancret's dance is exactly described in the fifth couplet, or movement, in *Le Cotillon, danse à quatre*, which was delineated and notated by Feuillet in 1705, in his *Quatrième Recueil de Danses de Bal pour l'Année* [FIGURE 67]: "The four dancers form a mill by joining their right hands (turning clockwise) then their left hands (turning counterclockwise)."[110] Our foursome is in the first movement of the couplet, holding their right hands and rotating clockwise. They will switch hands and reverse direction for their next movement. Then the next couplet

describes a ronde. The cotillon was accompanied by a melody whose refrain is quoted above and from which (according to Feuillet) it derived its name. Each couplet corresponded to eight measures of music.

What prompted this rarity, this special and unusual dance? One can only speculate, of course, but Lancret's work tells us that his choices were made deliberately. The paucity of images of this or similar foursome dances does make one wonder if it was the product of a commission, depicted at the request of a patron who was involved or interested in the theater and dance.

Lancret's reasoning in this case might be the most simple and direct sort for a painter—this dance step looked good. As an artist constantly in touch with the most popular performing arts, Lancret could pick and choose the most visually compelling forms for his scenes. A *moulinet* has distinct advantages as a pictorial device over the next couplet in the cotillon, a ronde. The mill shape, with the linked hands forming an X, provides a terrific centering device for a composition, a function it performs beautifully in the Getty painting [FIGURE I]. A ronde dance leaves an open space in the center. In the Dresden ronde [FIGURE 66], Lancret coped with this open space by inserting a majestic tree within the circle, as dancing around a tree is as old as dance itself. A ronde traps both hands of each dancer, forcing the participants into a particular and rigid alignment with one another and with the viewer. Not so the *moulinet*. Here the dancers have one hand left free to create a graceful accent to the steps, and the bodies can turn more freely with only one anchored hand.

The freedom of the dancing bodies provides us with another motive for the choice of the *moulinet*, as Lancret has used this freedom in a very specific way: as invitation and emblem. One of the dancers, the woman

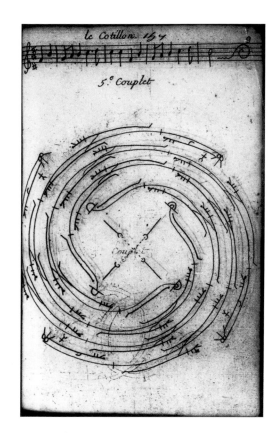

FIGURE 67
Raoul-Auger Feuillet, *Danse à quatre*, from *Quatrième Recueil de Danses de Bal pour l'Année* (Paris, 1705), p. 9, fifth couplet. Photo courtesy Jerome Robbins Dance Division, New York Public Library for the Performing Arts, Astor, Lenox, and Tilden Foundations.

in white in the center of the painting, has turned completely outward to face the viewer. This position is not one she would have taken in the actual steps of the dance itself. The cotillon and *contredanse* were noted for their social interaction and their lack of posed display. What has prompted this dancer to step outside the couplet, as it were?

Mainly, she has stepped out to invite us to The Dance. Every aspect of her posture welcomes us, the viewers, into the garden, into the dance. She alone of the four does not look at the dancer directly across from her. She turns out to us, looks right at us, and holds her skirt as if about to curtsy to us. As the cotillon and the *contredanse* were social dances easily learned and easily joined, her pose reflects this new level of dance popularity. As always, Lancret was aware of the most modern aspects of culture, and this frank invitation is dance at its most contemporary.

The woman has another role as well—that of Dancer, embodying Dance and standing in for all dancers. "O body swayed to music, O brightening glance, how can we know the dancer from the dance?"[111] Her white costume that sets her apart, her central location within the composition, her posture of display—all these aspects tell us that she is meant to be iconic. In her person, she embodies all that is Dance: its grace, beauty, authority, and emotional truth. This embodiment of Dance in a female form is strikingly contemporary, as it was a distinct change from the male-dominated ballet of the previous age. This focus on the female dancer in Lancret's painting coincides with and reflects a similar focus at the Opéra ballet, where female performers were enjoying a new prominence. This development was driven by the fame of the two most renowned ballerinas of the time, Marie-Anne de Cupis de Camargo and Marie Sallé.[112]

These two figures reformed the art of ballet for women. Marie Sallé captured a new grace and naturalism and altered the dress of ballerinas to a more natural silhouette. Her performances were praised for their emotional truth. La Camargo was renowned for the athletic agility of her steps, her quicksilver virtuosity, and her strong leaps. One contemporary observer said she "danced like a man." Both women are credited with shortening and simplifying the ballet skirt so that one

could observe their feet. It is perhaps no surprise that both women were closely linked to Nicolas Lancret in the decade of the twenties, when (as already noted) he painted portraits of both women, paintings that in their seamless blend of fact and fiction, of the portrait genre with the *fête galante*, placed him among the masters of portraiture of the age. He painted La Camargo first, in a work he then reproduced in paint at least twice more [see FIGURE 34]. He showed her on balance, in an energetic step that sends her dress flaring and swinging. The only choice for a pendant would be the equally celebrated Sallé [see FIGURE 35] (as Émile Dacier, who did an immense amount of research on Sallé, points out, "le public avait nommé le modéle [the public named the model])."[113] Lancret obviously intended to complete the portraits by referring them to one another, to the well-known differences between the two dancers and their styles. Sallé is all quiet poise, like her protectress, the cool and virginal Diana. She dances before a temple of Diana and is accompanied by the Three Graces. Although there is the remote chance that this setting refers to an actual role,[114] it is far more likely to refer to her character, as Voltaire described it in a 1732 letter: "The modesty of your nymph is expressed by the temple of Diana."[115] Voltaire introduced Lancret to Sallé and visited the studio when this portrait was being made, professing to prefer the Sallé image to that of Camargo:

> Ah, Camargo, how brilliant you are, but, great gods, how ravishing is Sallé! How light your steps, and how soft hers. She is inimitable, you are original. The nymphs leap like you, but the Graces dance like her.[116]

Might our dancer in white be a portrait, either of one of these two dancers or of another in the Opéra? Her prominence and outward gaze suggest such an identification, and indeed, Lancret did many other portraits of dancers. One such work, now in the National Gallery of Art in Washington, D.C. [FIGURE 68], makes a particularly interesting comparison to the Getty painting, as it is a portrait of Camargo in a much more substantial *fête galante* setting and accompanied by a partner. However, the portrait possibility does not seem to hold up for the

FIGURE 68
Nicolas Lancret, *La Camargo Dancing*, circa 1730.
Oil on canvas, 76.2 × 106.7 cm (30 × 42 in.). Washington, D.C., National Gallery of Art, Andrew W. Mellon Collection, 1937.1.89.

dancer in the white dress. Her features are too generic, too similar to the features of other Lancret female faces to reflect a specific individual. Lancret was a deft and fearless weaver of genres; repeatedly he made combinations of the *fête galante* with portrait and landscape in ways that were innovative and exciting—in the Washington, D.C., *La Camargo Dancing*, the setting and figure serve to enhance and describe a real dancer; in the Getty *Dance*, the setting and figure serve to define the dance itself and ask us to join.[117]

DANCE BEFORE A FOUNTAIN [FIGURE 1] HAS A CLOSE VARIANT, THE
Quadrille Before an Arbor now in Charlottenburg Palace, Berlin [FIG-
URE 32]. On first comparison, the similarities are obvious. The main
dancing group of four is present in both paintings, as are the four prin-
cipal courting couples, the one pair to the left of the main foursome,
and the three others on the right. All are in roughly the same position
and costume. One important change is in the dress of the main dancer.
In the Getty work, she is all in white. In the Berlin version, she is in
blue, silver, and salmon-pink, her costume coordinating with her part-
ner instead of contrasting to it, her figure blending in as opposed to
standing out. The musette player is there, the reclining boy in brown,
and the solitary spectator. The other crucial difference is in the format,
as the artist found one composition suitable to a horizontal painting,
and the other more appropriate to a vertical canvas. In the Getty hori-
zontal, the solid width of the fountain angles back from the right cor-
ner, giving the measure of the shallow stage of the clearing in front of it.
There is room in this spacious glade for a group of children to the right
and a seated man to the left, the kind of classic *repoussoir* figures a hori-
zontal composition calls for, which insist on the horizontal while allow-
ing the participants to wander naturally across the stage thus defined.

Equally, the Berlin composition insists on its verticality. The
space-defining fountain has been replaced with a very tall, elegant
statue of Bacchus and an even taller garden pavilion, whose treillage
construction allows it to blend in with the trees. Gone are the

FIGURE 69

Nicolas Lancret, *Dance in a Pavilion*,
circa 1724. Oil on panel,
130 × 97 cm (51¹⁄₈ × 38¹⁄₄ in.).
Stiftung Preußische Schlösser
und Gärten Berlin-Brandenburg,
Berlin, Schloss Charlottenburg.
Photo: Jörg P. Anders.

repoussoir children and seated man. The graceful inhabitants, so emphatic and central to the Getty composition, are here only a third of the image, which celebrates their garden as much as their dance. The graceful trunks of the trees are far more prominent, their swaying forms and elegant branches deliberately echoing the dance below, their frothy leaves overtaking the pavilion. The hint of more space is clearly implied by the pilgrims (once again a reference to the symbolic visit by lovers to the island of Cythera [see FIGURE 20]), who here head off down a hill.[118] The pair to this painting in Berlin, its pendant since its first known eighteenth-century sale, is another vertical work, *Dance in a Pavilion* [FIGURE 69]. This rare interior scene by Lancret is a sophisticated architectural composition with a ceiling painting drawn from Nicolas Poussin's *Time Rescuing Truth from the Attacks of Envy and Discord*, now in the Musée du Louvre.[119]

It seems clear that the Getty painting is the first version of the composition in *Quadrille*. The horizontal format is by far the most common in Lancret's oeuvre, his "comfort zone," if you will, and thus a far more likely format for a new composition. The garden staffage too, the balustrade and then the fountain, are his structures of choice, appearing with regularity in his gardens. Even in the shift from balustrade to fountain, the artist appears to be altering the essentials of a composition he is working up for the first time.

One wonders if the *Quadrille* in Charlottenburg was the result of a commission, the circumstances of which are now unknown to us.[120] The vertical format is a relative rarity in the *fête galante* work by Lancret, and one feels it must conform to the decorative needs of a patron. In the case of the *Quadrille*, the most likely sequence is as follows: Lancret completed a painting that pleased him (the Getty work) and, when commissioned for a work by an important patron, naturally used a recent composition that he considered very successful, reworking it for the requirements of the new venue. Lancret, like many other eighteenth-century painters, such as Chardin and Watteau, often made variants of his own work, as we have seen with *La Camargo*. These painters, after all, had no expectation that their paintings would ever meet again, in the same room or even in the same country!

The documentation on the two paintings now in Charlottenburg provides us with invaluable information about their date and, by extension, the date of the Getty painting. All three paintings must date from the first half of the 1720s. As previously noted, Lancret exhibited several times at the Exposition de la Jeunesse. His contributions are detailed in the newspaper of the time, the *Mercure de France*. In 1724, the *Mercure* noted that Lancret presented "a rather large arched (or curved, shaped) painting in which we see dancers in a landscape, with all the brilliance, novelty and gallantry the painter was capable of bringing to the pastoral genre."[121]

Some two decades later, Pierre-Jean Mariette, in his *Abecedario*, will describe two paintings by Lancret that he saw at the Exposition de la Jeunesse: "It is a full twenty-four years since he made his debut with

FIGURE 70
Eighteenth-century silvered
frame. Stiftung Preußische
Schlösser und Gärten Berlin-
Brandenburg, Berlin, Schloss
Charlottenburg.

two paintings, *A Ball* and *A Dance in a Grove*, two paintings that belonged to M. de Jullienne and then to M. le Prince de Carignan, and I recall that when they were exhibited in the Place Dauphine on the feast of Corpus Christi they earned him high praise."[122]

J. J. Guiffrey has plausibly suggested that Mariette was describing the 1724 exhibition (even though the *Mercure* mentions only one of the works).[123] Furthermore, it would seem certain that these two paintings are those currently in Charlottenburg [FIGURES 32 and 52]. They were purchased from the collection of the prince de Carignan for the collection of Frederick II of Prussia by his emissary, the comte de Rothenborg. The purchase is detailed in a letter from the comte to Frederick on March 30th, 1744: "I bought you two admirable paintings by Lancret, that have very charming and gay subjects; they are the two masterpieces of this painter; I have bought them from the estate of the late M. the prince de Carignan, who paid to the painter, in his [Lancret's] lifetime, the sum of 10,000 livres, while I have had them both for 3000 livres. It is very hard to find paintings by these two painters [i.e., Watteau and Lancret]."[124]

Christoph Martin Vogtherr has recently published the precise location among Frederick's many palaces for which these paintings were intended, in the *ovales speise-zimmer*, or oval dining room, of the Potsdam Stadtschloss. The works in Charlottenburg have been reunited with the frames made for them at the time by Johann August Nahl.[125] The existence of these frames, together with the eighteenth-century frame that still accompanies the Getty painting [FIGURE 71], provides a wonderful opportunity to imagine these paintings as they were meant to be seen. The German frames, made to fit the

FIGURE 71
Frame from Figure 1, Nicolas
Lancret, *Dance Before a Fountain*.

two new acquisitions and installed in 1744, are masterpieces of eigh-
teenth-century wood carving. They feature iconography that is suitable
for their paintings: for *Quadrille*, the grapes signify the presence of
Bacchus and the gardening tools refer to the garden environment; the
frame for *Dance in a Pavilion* has musical instruments, flutes, and so
forth.[126] Most interestingly, and in contrast to French interior decora-
tion of this period, the frames are silvered, not gilded. This silvering is
part of a decorative ensemble that encompassed the entire room. All the
frames on the eleven paintings intended for the room had silver frames,
the furniture had silvered mounts and carved decoration, and the wall
boiserie was silvered as well [FIGURE 70]. It is a marvelous effect, very
different from the warm tones of the gilding of much French *boiserie*, and
so suitable for Lancret's cool blues. The Getty painting, too, is in a
spectacular frame, certainly its original, this time in the gilded carved
wood more usual in French decorative ensembles [FIGURE 71].

Opposite:

FIGURE 72

Digit, "655" [detail of Figure 1].

FIGURE 73

Page from Frants Labensky inventory, 1797. St. Petersburg, The State Hermitage Museum.

IF SUCH LUMINARIES AS THE PRINCE DE CARIGNAN AND FREDERICK II owned the pair now in Germany, might someone equally exciting have owned the Getty painting? And how can this be determined? The search for the eighteenth-century provenance of a work of art is a bit like looking for a needle in a haystack, one formed of inventories, descriptions of homes and collections, wills, payment receipts, inscriptions on prints, and so on. It can be very frustrating, and often fruitless. In this case, however, a clue appears right on the work of art. Looking carefully at the lower left corner of the painting, one can clearly make out three numbers, "655," painted in red [FIGURE 72]. They appear to be an inventory number, painted in an eighteenth-century hand. Six hundred and fifty-five works of art in a collection of that time would describe a very large collection. However, work by Getty conservator Mark Leonard revealed something even more exciting—there had once been another digit [see FIGURE 8c, page 104]. It must have read, at the least, "1655"! Only a handful of royal or aristocratic collections approach such size. Julia Armstrong-Totten of the Getty Provenance Index, with help from intern Nadeja Prokazina, tracked down the significance of this number and was the first to determine what it meant for the location of the painting in the eighteenth century.[127]

This kind of provenance clue comes along very seldom, and it is quite amazing, for it indicates that the painting had once formed part of the Russian Imperial collection during the reign of the avid collector Catherine II, known as Catherine the Great. The Russian collections

were marked with red numbers as part of various inventory systems. The red numbers were applied to lower left or right sides of the front of canvases by at least three or four different hands. The number on the Getty painting corresponds to a painting in an inventory that was begun just after Catherine's death in 1796. This 1797 inventory was started by Frants Labensky, the Keeper of the Paintings, and went on for forty years, eventually to include some four thousand paintings, eight thousand drawings, and eighty thousand engravings. This inventory exists in manuscript only, at the Archives of the State Hermitage Museum,[128] and is not the same as the published (1774) or handwritten (1773–85) inventories of E. Munich (which include the paintings by Lancret that are still in the Hermitage collection today).[129] The curator at the Hermitage in charge of this part of the collection, Ekaterina Deriabina, confirmed to Julia Armstrong-Totten and Nadeja Prokazina, via e-mail, that

> There is a Lancret in the 1797 Labensky inventory with the number 3655 [FIGURE 73]. It is described there as "Pleasant gathering" and the dimensions given are 1 arshin, 5_ vershoks × 1 arshin 13 vershoks. She [Dr. Deriabina] explained that these are older Russian measurements and that sometimes mistakes or misspellings appear in the document. She suggested the dimensions could possibly be interpreted as either 96 × 129.5 cm or 96 × 136.5 cm; the latter is closer to the dimensions of the present size of our painting. She also checked the earlier Munich inventory, but in its manuscript form. E. Munich made this inventory from 1773 until 1785, and any acquisitions during this period would have appeared in the document. She

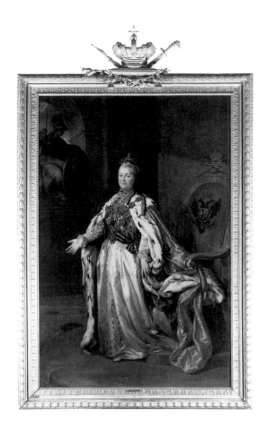

FIGURE 74
After Alexander Roslin (Swedish, 1718–1793), *Full-Length Portrait of Empress Catherine the Great of Russia.* Oil on canvas. Collection of the Marquess of Cholmondeley, Houghton Hall, Norfolk.

did not find a Lancret of this subject, which means that the Getty painting would have entered the collection after 1785. This narrows down considerably the period of time in which Catherine would have acquired this picture, since she died in 1796 [FIGURE 74]. Unfortunately, the Empress was not purchasing large numbers of paintings from a single collector during these particular years, and it is presently uncertain when and how she acquired our painting.[130]

Although it may never be possible to say with complete certainty how the painting entered the Hermitage, further research has allowed us to come up with a reasonable theory. One dealer, Johann Klosterman, active in St. Petersburg in the 1770s and 1780s, handled a great deal of French art,[131] including other paintings by Lancret, and sold a number of paintings to Catherine herself. Very little of the archival material on this important dealer remains—and what does exist is fragmentary—but what we know fits with his having been the purveyor of the Getty painting into Catherine's hands.

Many important aspects of the collecting of Western art in St. Petersburg in the eighteenth century have been thoroughly studied, but there is much work still to be done. One knows, for example, that Catherine II purchased well-known collections *en bloc* (those of Brühl in 1769, Tronchin in 1770, L. A. Crozat, Baron de Thiers in 1772, and Walpole in 1779, for example), but many of her smaller purchases remain undetailed. Much archival material has been lost over time, and much that remains is in Russian. Vladimir Levinson-Lessing, the director of the Hermitage in the mid-twentieth century, had extensive knowledge of the picture collection's history and of the corresponding

archival material. He wrote the *History of the Hermitage Picture Gallery, 1764–1917*, which was published posthumously in Leningrad in 1985.[132] The second chapter deals with the Hermitage Gallery in the eighteenth century, and there are several appendices relating to this chapter. The book contains essential information about this time and identifies some of the key figures in the trade of art in St. Petersburg, especially (for our purposes) Klosterman, a Dutch dealer in books, prints, and paintings who moved to St. Petersburg in 1768, and his partner, Denis Ivanovich Fonvizin (1744/5–1792), a diplomat and satirical dramatist from a noble family. According to Levinson-Lessing,

> At the end of the eighteenth century, it frequently happened that paintings were brought to Russia for sale. Some dealers engaged particularly in the trade in works of art, usually combining this with dealing in books. The leading dealers were Klosterman and Weitbrecht. Klosterman, who arrived in St. Petersburg in 1768 and had a bookshop on Nevksy Prospekt and then on Novoisaakievskaya, brought whole groups of paintings from abroad. Supplying Catherine quite regularly with books and prints, he also sold the Hermitage paintings on several occasions. The writer D. I. Fonvizin, who was closely linked to Klosterman, was also very closely connected to his trading in paintings."[133]

It appears to have been Fonvizin who initially conceived of a commerce in works of art. He was very well connected, acquainted with such influential collectors as A. S. Stoganov and D. S. Golitsyn, and was very well traveled. He met Klosterman in Paris in 1777, and at some point Klosterman joined the enterprise, becoming its sole proprietor on Fonvizin's death in 1792.[134] According to Klosterman's notes, consulted by Levinson-Lessing, the two traveled together to shops and auctions, or Fonvizin would send Klosterman off alone, with instructions.[135]

In 1782, we have the first document of a sale from Klosterman to the Imperial collection, to Catherine II. To quote Lessing on this source:

This invoice in French gives a brief list of the paintings with an indication of the author's names, the title and price in roubles. The paintings are listed in growing order of numbers placed to the left of the author's name but has a number of omissions indicating that the list is but a selection from a more extensive list, which would seem to have consisted of seventy-five items. The paintings, as was often the practice, were looked at by Catherine accompanied by the Keeper of the Gallery, the artist and restorer Martinelli. After viewing Catherine noted in the list that which she wished acquired. Paintings were viewed on the ship delivering them or were sent to the Hermitage and in a few cases were viewed in the shop. We know Catherine visited Klosterman's shop.[136]

This invoice of forty-six paintings sold to Catherine and dated September 10, 1782, includes, under number thirty-six, two paintings by Lancret that remain in the Hermitage today entitled *Spring* and *Summer*, from a set of *Four Seasons* commissioned by Leriget de la Faye. They are listed in La Faye's posthumous inventory of 1731 (under no. 27); then all four reappear in 1753 in a sale in Paris (*Affiches, Annonces et Avis divers* [1753], p. 92, under Ventes), and subsequently in the sale of the architect Vigné de Vigny (Paris, April 1, 1773, catalogued by P. Remy, no. 100, all four sold for 1785 livres). The Vigny sale is the last known appearance of the works as a group. *Autumn* [see FIGURE 5] is now in the collection of the Homeland Foundation in New York; *Winter* remains lost. Levinson-Lessing notes the provenance of *Spring* and *Summer* from La Faye's collection, and their subsequent ownership by the architect de Vigny.[137] They are listed together on the invoice under one number at a cost of 680 rubles. Also listed is the wonderful pair of Sultana paintings by Carle Van Loo, from the collection of Madame de Pompadour, that still hang in the Hermitage today.

There is ample evidence that this invoice does not contain all the paintings sold by Klosterman to Catherine. Levinson-Lessing notes that other documents describe payments to Klosterman from Catherine for works of art; these works not specified.[138] As further proof, several paintings in the Hermitage collection today, paintings not found on any

surviving documents relating to Klosterman, bear an old inscription in black paint on the back: *14.Kol.Klostermana*, or from *Klosterman of the 14th College*.[139] Furthermore, according to Levinson-Lessing, "Inscriptions are found on paintings which were not included in Munich's manuscript catalogue that were acquired between 1782 and 1786. In the manuscript catalogue of 1787 [i.e., the Labensky catalogue] these paintings are indicated without reference to their provenance."[140] In other words, paintings bought from Klosterman were included on the Labensky inventory without reference to their provenance. Sadly, as Levinson-Lessing states, "With the exception of this document [i.e., the invoice] cited above, we have no genuine invoice from Klosterman which would allow us to establish exactly which objects, particularly paintings, were purchased by Catherine."[141] As an educated guess, however, this provenance has much merit.

Investigation into how the painting may have entered Catherine's collection results in useful information about collecting in Russia at that time and provides a solid possibility for the avenue via which the Getty painting traveled, but it still does not tell us where the painting came from in the first place. Who was the first owner? While the circle of known collectors who bought Lancret's work is not a large one, it contains some illustrious names. One finds such luminaries as Pierre Crozat, who was a crucial figure in the art world of that time, and whose city and country salons were so memorably recorded by Lancret [see FIGURE 42]. There is also the wealthy financier Peyrenc de Moras, who, as has already been discussed, commissioned a stunning decorative cycle of ten paintings from Lancret [FIGURE 75].

There are some criteria the first owner must have met. In the first place, he or she must have been reasonably wealthy, for Lancret became a high-priced artist very quickly. From Lancret's earliest independence as an artist, we have evidence of his interest in material success. After all, he was not from an affluent family, and he needed to earn a proper living. We have already noted Lancret's industrious work habits and his early attempts to market his work to patrons of a very high level. Add to this his consistent employment of printmakers to reproduce his work, to

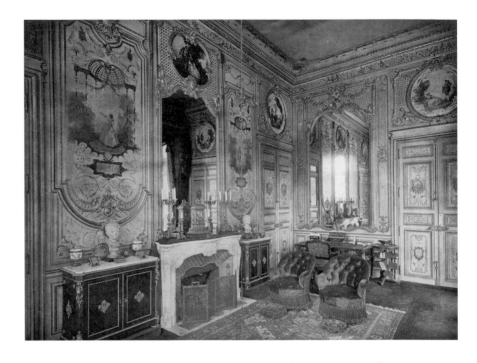

FIGURE 75
Jacques V. Gabriel, architect,
Nicolas Lancret and Claude III
Audran, painters; Jules
Degoullons, André and Mathieu
Legoupil, sculptors; first-floor
cabinet in the corner (before
dismantled), Maison Peyrenc de
Moras, no. 23, Place Vendôme
(1724), from E. Féral, *Notice sur un
très beau salon décoré par Lancret dont la
vente aura lieu à Paris . . . le Mercredi 27
Mai 1896* (Paris, 1896). Galerie
Georges Petit. Photo: Arat and
Architecture Collection, Miriam
and Ira D. Wallach Division of
Art, Prints, and Photographs,
New York Public Library, Astor,
Lenox, and Tilden Foundations.

make more pieces to sell, and to advertise his paintings; his aggressive prosecution of the counterfeiter of one of his successful prints; and his continuous creation of paintings with cyclical themes that could only be bought in groups (four paintings or prints costing rather more than one), and one builds the picture of a man bent on achieving both monetary and critical success from his earliest days as an artist. These goals he accomplished. His prints were best-sellers, and his paintings were expensive. According to Mariette, "He acquired in rather short order a respectable fortune."[142]

In fact, as luck would have it, we can determine quite closely just how costly the Getty painting was likely to have been at the time, as the owner of its close variant complained of that work's expense. As already noted, the Prince de Carignan paid the tremendous sum of 10,000 livres for the *Quadrille Before an Arbor* and the *Dance in a Pavilion* to the artist himself, when the usual cost for an easel painting was around 500–800 livres!

The collector must have been interested in this relative newcomer and this novel genre at a fairly early moment in the popularity of both.

And this person probably was not the owner of the variant (which knocks out the Prince de Carignan, otherwise a good candidate).

One name among Lancret's early supporters especially stands out, and must be a serious contender for first-owner status, that of Jean-François Leriget de la Faye. La Faye was, by all accounts, a "Renaissance man"—a military man; a successful diplomat; a connoisseur of music, ballet, and theater; a voracious collector; and a poet with enough merit to claim a seat at the Académie Française. After years of service to the Crown, he returned to Paris, to a hotel on rue de Sèvres, where, according to one biographer, "He assembled a rich collection of paintings, engraved stones, bronzes, marbles, porcelains, and a valuable library. His collections were accessible to all, to the curiosity-seeker as well as to scholars."[143]

Jean le Rond d'Alembert (1717–1783), in his biographies of the members of the Academy, asserts that La Faye was truly a "man of taste," preferring "the masterpiece of a virtually unknown painter to a mediocre painting by a celebrated artist,"[144] an interesting comment in light of his early sponsorship of Lancret. He also had a chateau at Condé-en-Brie. Voltaire characterized him thus:

Il a réuni le mérite
Et d'Horace et de Pollion[145]
Tantôt protégeant Apollon,
Et tantôt marchant à sa suite.
Il reçut deux presents des dieux,
Les plus charmants qu'ils puissant faire:
L'un était le talent de plaire;
L'autre le secret d'etre heureux.[146]

La Faye's particular interest in artists of the *fête galante* genre is hinted at by the fact that he patronized and housed Bonaventure de Bar, a close follower of Watteau's; in fact, at the time of his death, de Bar was living in La Faye's Paris home. There are several traces of La Faye in Lancret's early career. His commission of the monumental Seasons [see FIGURE 5] stands as the first hallmark of Lancret's true success. These paintings must surely date from around 1719–21. Ballot de Sovot and

Dezallier d'Argenville both relate the impact that the first two paintings of the set had on La Faye: "When M. Lancret had the second painting brought to M. de la Faye, he was so moved by his progress that he cancelled the original terms and gave him double the price they had agreed on. Would a Medici have done better?"[147] Lancret impressed his patron not only with the quality of his own work but also with his eye for the work of others. La Faye was delighted when he showed Lancret an expert copy in his own collection, and Lancret spotted it for a replica—the only visitor to make that discovery.[148] He and Lancret shared a passion for the theater and ballet as well, and it has been suggested that La Faye was one of La Camargo's lovers. He was the first owner of her portrait.[149]

La Faye was interested in Lancret's work at exactly the moment that the Getty painting must have been made; he was actively commissioning and purchasing works from the artist during this period of his first success. La Faye was building and decorating at this time as well. According to Rochelle Ziskin, an art historian specializing in the building and decorating boom in Paris during the first half of the eighteenth century, "He [La Faye] first bought a house on the rue de Sèvres in 1717. He added another house on the rue du Cherche-Midi in 1719. In 1719–20, all of the members of the circle were awash in money from speculation in Law's bank and trading company. It would seem likely to me that Leriget might have commissioned decorative work during the early 20s."[150] And there is the matter of the oddly conspicuous white dancer. La Faye was passionately interested in dance and ballerinas, and he would have found the prominence of the figure in the Getty painting exceptionally appealing.

Unfortunately, La Faye's inventory lists no artists' names.[151] The *Four Seasons* can be located there because one knows from other sources that those paintings were made for La Faye. Upon his death, the collection was dispersed. To turn again to Dr. Ziskin: "Leriget bequeathed to the Comtesse du Verrue twelve paintings of her choice. The rest went to his nephew (also J.-F. Leriget de la Faye) who seems to have sold many works from his uncle's collection soon after Leriget's death, through a dealer."[152]

Ironically, La Faye (as we have just seen) commissioned the two Season paintings that went to Catherine the Great via Klosterman, although one cannot go too far with that coincidence—after all, in that case two sales and fifty years intervened between La Faye and Catherine. However, one might imagine Klosterman, as a good dealer would do even now, seeking objects with such a desirable provenance and noting the benefits of that provenance to his exalted patroness.

The next question to be addressed is how the Getty painting left Russia, winding up in the home of Robert Herbert, twelfth Earl of Pembroke (1791–1862), at 19, Place Vendôme, in Paris.[153] One might suggest, as Julia Armstrong-Totten has explained, that the work left during the wholesale deacquisition by Nicholas I of his mother's collection, which began in 1854, as the painting is not mentioned in an 1859 inventory of the Hermitage Museum. The painting is not, however, listed among the items sold. It is possible that Nicholas gave it away, and the recipient then sold it.[154]

Another possibility suggests itself, however, given that the painting is next documented in the Robert Herbert collection. Robert Herbert's father, George, the eleventh Earl of Pembroke (1759–1827), married into one of the great aristocratic Russian families when he wed Catherine Vorontsov, or Woronzow (1783–1856), the daughter of Simon Woronzow, the Russian Ambassador to London.[155] Catherine was George's second wife, and thus the stepmother of Robert. One wonders if the painting might have been a gift from the Imperial family to Catherine on the occasion of her marriage to George in 1808. Her family had very close ties to the Imperial family. She might have given the painting to Robert directly, as he had a taste for French things. Then the painting would not have been part of the entailed Pembroke properties and could be sold on Robert's death (which we know it was).[156] This remains a speculation, however, as searches among the archives of Wilton House and Pembroke House have turned up no mention of the painting, and Labensky makes no mention of this departure in his inventory.[157] Still, it is one possibility for the path of the painting out of Russia.

Lord Robert bought the house at 19 Place Vendôme sometime after 1819 and furnished it lavishly. He died there. This house was built by Pierre Bullet next to the house of Antoine Crozat (brother to Pierre, and even more rich), and given to Crozat's daughter on her marriage to the comte d'Evreux. It is ironic that the Lancret would return to the home of some of the artist's greatest patrons, now owned by an Englishman! In Herbert's sale, the Lancret is lot 16, titled *Danse dans le parc*, and it was bought by Laneuville (presumably Ferdinand Laneuville, the expert for the sale).[158] The next owner was Edouard Fould (1834–1881), who might have used Laneuville as an agent for the purchase. Fould purchased a Pater (lot 10), *Réunion dans le parc*, from the sale as well, and hung the two works as pendants (although the Pater was not in the Hermitage with the Lancret, and the two must have come together only at the Herbert house). In a sale in 1869,[159] the Lancret and the Pater were both sold (lots 10 and 11, respectively) and bought by M. Rouzé, a jeweler for the Rothschild family[160] and presumably acting as an agent here for Baron Gustav de Rothschild (1829–1911), the next owner. His son Robert (1880–1946) inherited the Lancret on Baron Gustav's death.[161] It remained in the Rothschild family until the Getty acquired it in 2001.

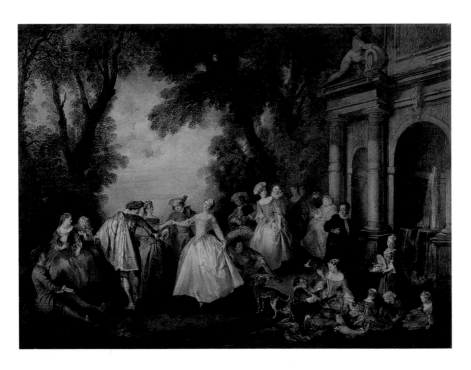

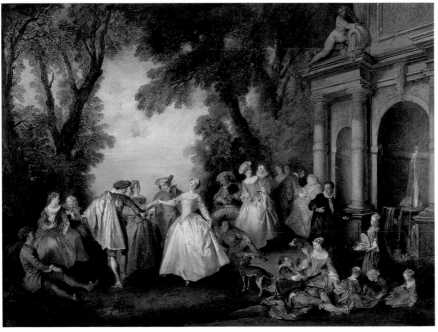

A NOTE ON THE STUDY AND TREATMENT OF NICOLAS LANCRET'S "DANCE BEFORE A FOUNTAIN"

MARK LEONARD

THE TECHNICAL STUDY OF A GREAT WORK OF ART SUCH AS NICOLAS Lancret's *Dance Before a Fountain* follows a path of discovery during the time the painting is in the conservation studio. In much the same way that the best of old master paintings strike a chord of familiarity in all of us, the secrets that those same pictures reveal during their often lengthy periods of restoration come to have, in restrospect, a similar sense of "inevitability." For the paintings conservator, much of the true joy of the restoration process stems from an evolving understanding of the work of art as the issues that could only be guessed at initially—or even new and completely unexpected ones—gradually shed their cloaks of obscurity and become clear during the very intimate time that the painting is undergoing treatment.

It was evident from the moment that the *Dance Before a Fountain* arrived in the paintings conservation studio of the J. Paul Getty Museum that this was a major picture which remained in a very good state of preservation. Although covered with a darkened and yellowed varnish [FIGURE Ia]—as well as broad areas of heavy-handed repainting—it was still apparent through this obscuring veil that the picture had not suffered from cleaning damage in the past. The thin glazes and scumbles used throughout the modeling of the flesh tones, fabrics, and atmospheric landscape setting remained beautifully intact.

Lancret created his paintings by building up delicate and translucent layers of paint, applied thinly, one layer on top of the other, until he achieved a sense of fluttering, flickering light dancing across the

FIGURE Ia
Dance Before a Fountain before treatment.

FIGURE Ib
Dance Before a Fountain after treatment.

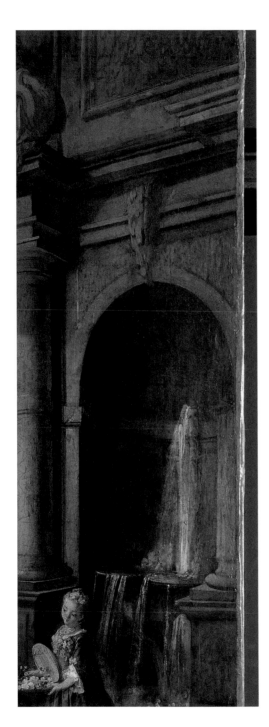

FIGURE 2

Dance Before a Fountain before
treatment; detail of right edge.

96

surface of the picture.[1] The seemingly ethereal nature
of the handling of the paint often resulted in pictures
that were easily damaged during attempts at cleaning. In
the past, these fragile layers of color were often dis-
turbed by the use of strong solvents, which could swell or
even dissolve the paint, or abraded by the use of a clean-
ing tool (such as a cloth or cotton swab), which could
easily wear away the upper layers, destroying the illusion
and leaving behind only ghostlike impressions of the
original surface. Fortunately, this type of damage had
not occurred with the *Dance Before a Fountain*: the delicacy
and shimmer of the original handling remained clearly
intact below the discolored layers of varnish.

The most important tools that we have for the study of
a picture are, of course, our own eyes. They provide us
with a direct link to the hand of the artist, and what they
tell us shapes our most profound experiences with a
work of art. Yet there are, as well, a number of techni-
cal tools that can provide helpful additional informa-
tion while studying a picture. Many of these analytic
techniques proved useful during the months that the
Dance Before a Fountain was in the conservation studio.

Prior to the beginning of treatment, the picture
was viewed under ultraviolet light, which confirmed the
presence of areas of repainting scattered across various
parts of the surface. These were most notable on the
right-hand side of the fountain and in scattered—yet
minor—areas of abrasion and loss throughout the
composition.

An X-radiograph was taken, which in this case revealed very little—most likely because of the presence of a large amount of lead white in the ground layer, which blocked the penetration of the X-rays and prevented any changes in the paint layer from registering in the radiograph image. But the X-ray did suggest that the repainting on the right edge covered a significant amount of original paint and that it had been applied in a broad fashion in order to compensate for a cluster of tiny flake losses that had occurred at some point in the past along the right side of the fountain [see FIGURE 2, and the corresponding cleaned-state detail in FIGURE 6b].

These particular damages had been somewhat clumsily overpainted: many islands of original paint were covered in the process, and the architectural structure of the right side of the fountain was consequently misinterpreted. Logic suggests that the right side of the fountain would have originally been a mirror image of the left side of the fountain; in the process of overpainting, a previous restorer had reworked the column at the far right into a truncated pilaster, and the upper right portion of the architecture (just above the archway) was reduced to an unarticulated, flat plane.

Infrared reflectography proved to be a particularly useful analytical tool in the study of other areas of the *Dance Before a Fountain*. This technique makes use of a digital camera that has been equipped with an infrared-sensitive detector [FIGURE 3].[2] Because various materials—such as pigments and paint media—both reflect and absorb light in the infrared range in different fashions, infrared reflectography can often reveal *pentimenti*—or places where the artist changed his mind during the course of painting—hidden beneath the surface. As noted earlier in this volume,[3] infrared reflectography revealed an architectural balustrade that Lancret had originally painted behind the group of figures just to the left of the fountain [FIGURES 4a and 4b]. He then chose to paint out this architectural detail, opting instead for an entirely wooded setting as a backdrop for the figural group, perhaps because it provided a more lyrical and atmostpheric background for the scene.

When the infrared camera targeted the very center of the picture,

it was discovered that the woman at the left of the central group of figures originally wore a bracelet, or perhaps just a thin ribbon, above the wrist of her outstretched arm [FIGURES 5a and 5b]. This small detail was a significant one—given the importance of the central quartet—and it may have been judged by Lancret to have been too distracting. He opted to paint it out, thus ensuring that our attention would be focused toward the subtle ballet of interlocked hands that serves as the compositional and emotional center of the scene.

The technical tool that provided the most telling results in the study of this picture was the stereomicroscope, which allowed for analysis of the paint surface under high magnification. Prior to treatment, use of the stereomicroscope confirmed that much of the overpainting covered areas of well-preserved original color—and even more importantly, reconfirmed that the delicate original paint surface remained in an

exceptionally good state overall. During the course of treatment—as will be discussed further below—the stereomicroscope also revealed a crucial detail concerning the picture's history.

A basic precept in modern conservation ethics dictates that everything that a conservator does to a work of art must be reversible. Materials added to a picture (such as new layers of varnish or paint used for retouching areas of loss) must remain easily undone so that any trace of the restorer can be removed in the future. The only real exception to this rule arises during cleaning, which, because it involves the removal of materials that cannot be replaced, is by definition an essentially irreversible process. This is one of the reasons that cleaning issues have historically been among the most emotionally charged topics in the field of conservation.

Cleaning is rarely a simple removal of a discrete layer of discolored varnish from the surface of a painting. The interrelationship between the varnish and the paint layers can be exceptionally complex, and the varnish and the paint are often intimately bound in ways that can make cleaning very difficult (and in some cases technically impossible). Although the restorer may be equipped with a battery of objective scientific tools for the study of a picture, cleaning is essentially a subjective process; the decisions made during cleaning, therefore, rest in the hand, eye, and discerning judgment of the restorer.

Fortunately, the varnish and overpaint layers in the *Dance Before a Fountain* were found to be readily soluble in very mild solvent mixtures, and the original oil paint surface was not susceptible to abrasion or damage from the mild mixtures required to remove the soft

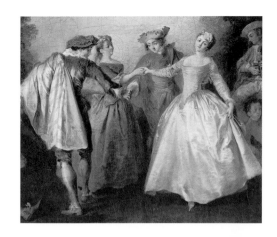

FIGURE 5a
Detail of central dancing group in normal light.

FIGURE 5b
Detail of central dancing group from an infrared reflectogram showing the bracelet that Lancret later painted over.

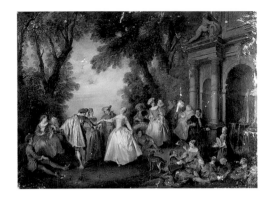

FIGURE 6a
Dance Before a Fountain in cleaned state.

FIGURE 6b
Detail of the right edge of the painting in cleaned state.

resin varnish. This meant, in this case, that the cleaning could progress in a straightforward fashion.

Cleaning can also be among the most satisfying stages in the treatment of a work of art; the picture literally reveals itself during the removal of the veils of obscuring varnish and repainting. Cleaning of the *Dance Before a Fountain* brought about not only a color change as a result of the removal of the heavily yellowed coating but also produced a spatial change, as the opaque old varnish layer had tended to flatten out the scene visually. The cool, silvery atmosphere of Lancret's original conception of the composition emerged as the yellowed fog of varnish was gently removed. A sense of depth and softness returned to the scene, and the delicacy and finesse of the original handling became even more apparent [FIGURE 6a].

Cleaning also revealed, as anticipated, that the fountain at the right edge had been heavily—and mistakenly—overpainted. As the overpaints were removed, the true outlines of the fountain reappeared, confirming that the correct architectural structure at the right side was, indeed, the mirror reflection of the architectural motifs at the left side of the fountain. Despite the scattered damages [FIGURE 6b], the strength of the original still dominated, and the more complex initial profile of the fountain was clear. Concurrent art-historical sleuthing had first noted similarities between the appearance of Lancret's architecture and an image of a specific fountain seen in an engraving made by Jean Marot in 1660 [see FIGURE 49, page 54].[4] As the cleaning and restoration progressed, it became even more incontestable that this was, in fact, a real and recognizable architectural setting—the Fountain of Maria de' Medici in the Luxembourg Gardens.

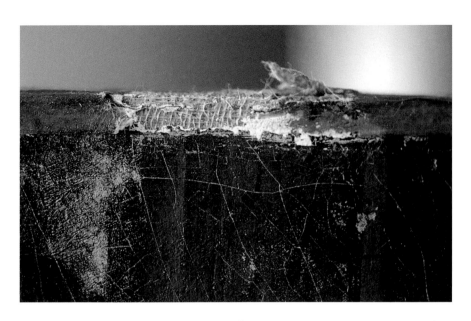

FIGURE 7 101

Detail of gauze at the edge of the
painting in cleaned state.

As often happens during the course of a treatment, cleaning did reveal
some surprises. After removal of the overpaints, some of the old, lumpy
filling material that a previous restorer had improperly applied to the
paint losses—to bring the level of the loss into plane with the surface of
the remaining original paint—was softened and removed. This revealed
a layer of open-weave gauze fabric below the putty. Further investiga-
tions at the edges of the canvas exposed a continuous layer of gauze lying
beneath the brown paper tape that had covered the tacking edges [FIG-
URE 7]. The presence of this gauze indicated that the entire paint layer
had been most likely removed from its original support (which also
would have been linen) and placed onto a new piece of linen fabric—a
process known as *transfer*. A layer of gauze was used traditionally as an
interleaf during this process, and its presence usually provides a firm
indication that a transfer has taken place.

Transfer was a structural conservation technique that was invented
in France in the mid-eighteenth century (where it was known as *trans-
position*).[5] By the mid-nineteenth century it had become a very popular
treatment throughout Europe and Russia.[6] It was most commonly used
as a treatment for panel paintings. Wood panels were affected by even

small changes in temperature and humidity, meaning that—before the invention of modern interior environmental control methods—changes in climate (from warm, wet summers to dry, cold winters, for example) could produce splits in the wood, the opening of joined planks, and the warping of flat boards. Such occurrences were not only unsightly but could also wreak havoc with a delicate paint surface, causing extensive flaking and loss of paint. Similar structural problems could also develop with canvas supports, particularly if the canvas was responsive to fluctuations in humidity or if the paint layer had an inherent tendency towards flaking.

The transfer process involved preliminary application of a protective, reversible facing made from layers of paper and glue on the surface of the painting; the fabric support (as in the case of the *Dance Before a Fountain*) was then slowly—and painstakingly—shaved away from the back until the reverse of either the ground or the paint film was exposed. A layer of gauze was then applied to the exposed reverse of the painting to act as an interleaf, and a new layer of fabric was attached by means of adhesives. The transferred painting was attached to a new stretcher, and, finally, the protective facing was removed from the surface.

Transfer has largely fallen out of favor today, as much less invasive structural treatments have been developed and modern climate control systems have helped to reduce fluctuations in temperature and humidity in interior environments. It has also been recognized that removal of an original support not only violates the "irreversible" rule of modern conservation but can, if inexpertly executed, irretrievably alter the surface texture and appearance of the original paint layers.

Fortunately, the transfer of the *Dance Before a Fountain* was done with exceptional skill and care, and it left no visible distortion or alteration of the surface. It may have been necessitated because of the flaking problems that had developed in scattered areas of the picture, although this is pure speculation. The transfer was most likely carried out in France, toward the middle of the nineteenth century, as the stretcher design was typical of those used in France during that time.[7] The transfer remained undetected until the telltale layer of gauze was discovered during the recent cleaning.

The most exciting discovery to be made during the cleaning of *Dance Before a Fountain* came about during the removal of the heavy areas of overpainting surrounding the red inventory number in the lower left corner of the picture. Prior to cleaning, the area of landscape just to the left of what appeared to be simply the number "655" was covered with very broad overpaint, just as had been found in other areas of the picture [FIGURE 8a]. When the heavy overpaints in the surrounding landscape were removed, the true extent of the damage was revealed: as elsewhere, a number of small islands of original paint were found to remain in the areas of loss. Most importantly, some of these tiny paint fragments included pinpoint remnants of a vermilion paint—visible under the stereomicroscope [FIGURES 8b and 8c]—that clearly matched the original paint of the "655." This immediately suggested that there must have been another digit in front of the six, meaning that this was not a number in the six hundreds, but that it was an inventory number in the thousands.

Study of the surface with the stereomicroscope during cleaning revealed that part of the "655" had been damaged and reconstructed at one point (the original upper portion of the "6," for example, remained intact [FIGURE 8c], but the lower half of the number had been reconstructed with a red paint that was slightly grayer in color than the original and did not match the opaque, enamel-like character of the original vermilion surface) [FIGURE 8b]. A larger area of loss ran through what would have been the first digit of the inventory number just to the left of the "6," and although tiny original fragments of paint remained, the previous restorer chose to simply paint them over, as they did not provide enough information on their own to reconstruct the original number.

FIGURE 8a
Detail of the lower left corner of *Dance Before a Fountain* before treatment.

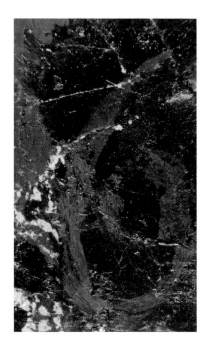

FIGURE 8b
Micro-detail of the painting's red inventory number after cleaning.

FIGURE 8c
Photoshop overlay highlighting areas of original paint in the number "6" and identifying remnants of the first (now missing) digit.

FIGURE 8d
Photoshop overlay highlighting areas of reconstruction in the number "6."

As noted earlier in this volume (see pages 82–83), Julia Armstrong-Totten of the Getty Research Institute, having learned that the picture must have once been part of an exceptionally large collection, was able to trace it to a 1797 inventory of pictures that had belonged to the Russian Imperial collection of Catherine the Great. That collection, in 1797, included a work by Lancret, which had been identified with the number "3655."

After cleaning, the restoration was completed with proper refilling of the losses, careful retouching of the scattered damages, and final application of new layers of varnish to provide depth and saturation for the paint layer. Given the fine state of the original surface in the *Dance Before a Fountain*, these steps in the treatment easily reunified the composition into a seamless whole.

The retouching process began with inpainting of the smallest losses. Following this path ensured that the picture itself would lead the

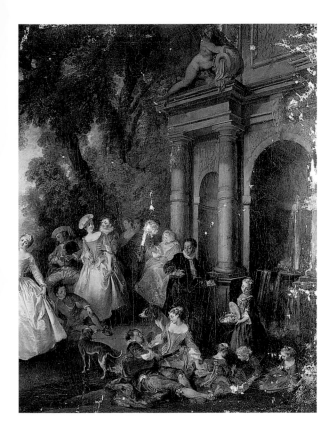

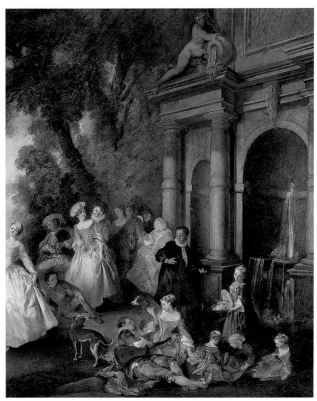

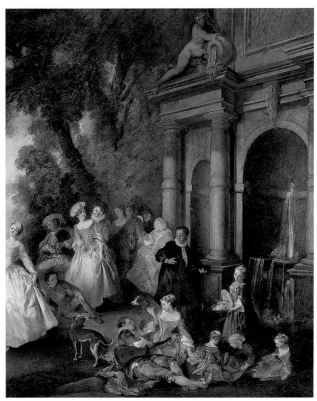

way through its restoration as the the small clusters of damages were knitted together and the original surface slowly regained its visual strength. Reconstruction of the correct architectural configuration at the right side of the fountain was led entirely by the increasing dominance of the original and required no invention or speculation as to Lancret's intent [FIGURES 9a and 9b].

The treatment came to a conclusion when the picture was replaced in its magnificent carved and gilded eighteenth-century frame. Original frames were often separated from the pictures for which they were made, as the desire for a particular style of frame shifted with changes in taste through the generations. In the case of the *Dance Before a Fountain*, the original frame remained with its intended work of art. This was

FIGURE 9a
Detail of architecture in the painting in cleaned state.

FIGURE 9b
Detail of architecture in the painting after treatment.

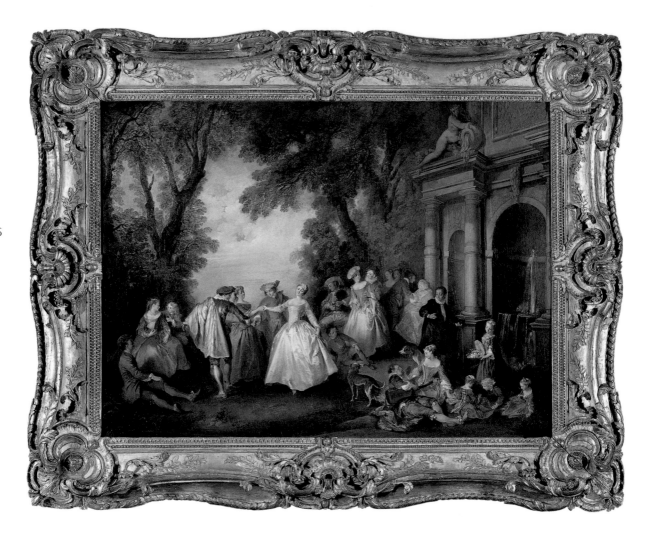

FIGURE 10
Dance Before a Fountain after
treatment, in frame.

fortunate, not only from a historical perspective but also from an aes-
thetic one: the sophisticated, fluid patterns of the frame elements echo
the lyrical movements of the figures within the painting, and the faceted
reflections from the frame's intricately gilt surfaces complement the
flickering light created by Lancret's shimmering and magical brush-
work [FIGURE 10].

1 For the Cleveland paintings, see *Cleveland Museum of Art Catalogue of Paintings: Part 3— European Paintings of the Sixteenth, Seventeenth and Eighteenth Centuries* (Cleveland, 1982), pp. 82–87. Other examples in American museums include paintings in Toledo, for which see *Toledo Museum of Art: European Paintings* (Toledo, 1976), pp. 91, 195; in Richmond, Virginia, for which see Mary Tavener Holmes, *Nicolas Lancret 1690–1743* (New York, 1991), pp. 84–85; and in Indianapolis, for which see Holmes, *Lancret* (1991), pp. 94–95.

2 For the Boston holdings, see Eric M. Zafran, *French Paintings in the Museum of Fine Arts, Boston, Vol. I: Artists Born before 1790* (Boston, Massachusetts, 1998), pp. 87–93.

3 See Holmes, *Lancret* (1991), pp. 67–69 and 76–77.

4 Ibid., pp. 58–59.

5 A drawing for a bagpipe player very similar to this one was in Galerie L'Estranger, Paris, in December of 2001; it is probably a preparation for this painting. Lancret used the figure (and probably the drawing) again, for example in *The Luxembourg Family* in the Virginia Museum of Fine Arts, Richmond. Like Watteau, Lancret prepared his paintings by making chalk drawings of single figures or couples, but rarely of compositions. He often kept the drawings (some two thousand were in his own collection at the time of his death) and used the same figures more than once. For a painting as elaborate as the Getty *Dance*, Lancret must surely have made several drawings; his drawings are scattered throughout the world in private collections and museums and number in the thousands.

6 One scholarly viewer has suggested that this couple be interpreted as a variation of the "predatory male suitor" theme, a theme that this viewer correctly asserts is present numerous times in the work of both Lancret, in *The Bourbon-Conti Family* in the Krannert Art Museum in Champaign, Illinois, for example, and Watteau, in *Le Faux Pas* in the Louvre, Paris, for example. To this author, however, the interchange between the pair seems entirely congenial, their faces revealing no stress, and their gestures affectionate and non-violent. This view is shared by the Watteau authority, Donald Posner, conversation with the author, December 9, 2004.

7 The red heels, or *talons rouges*, were an element of French court costume, denoting those who had been presented, and became a feature of the paintings of this period that show scenes of the affluent classes, such as those of Jean-François de Troy (seen on the suitor in *The Garter* of 1724, in a private collection, for example).

8 This figure bears a strong resemblance to the few certain images we have of Lancret and, with his air of detached observation and his dark clothing, bears all the hallmarks of being a self-portrait inserted into this painting. There are other instances where one might suspect a self-portrait in a painting by this artist, for example, the figure in the left corner looking out at the viewer in the Washington, D.C., *La Camargo Dancing* [FIGURE 68]. The function of these figures, as Eric Zafran astutely points out (in *The Rococo Age: French Masterpieces of the Eighteenth Century*, exh. cat. [Atlanta, High Museum of Art, 1983], p. 112), is to "appear[s] as both host and creator of this delightful event."

9 Lancret made use throughout his career of the traditional iconography of the ages of man to elaborate the relationships and narratives within his work and to enhance his descriptions of coming of age and courtship rituals. Girls on the edge of puberty are gathering flowers in preparation for entry into the courtship of the next stage of their life (the most famous expression of this ancient trope being Robert Herrick's "Gather ye rosebuds while ye may"); young men in their prime wear lusty red and play at games appropriate to their age and virility; the old take on sedentary occupations or sleep. For more discussion of this iconography, see Holmes, *Lancret* (1991), pp. 14–18, and 82–84.

10 Sarah R. Cohen, *Art, Dance and the Body in French Culture of the Ancien Régime* (Cambridge, 2000), p. 9.

11 A collection of these images and a discussion of their importance to the imagery of the *fête galante* can be found in *Watteau et la fête galante*, exh. cat. (Valenciennes, Musée des Beaux-Arts, 2004), pp. 108–11, 174–77, and 238–41.

12 See especially Oliver T. Banks, *Watteau and the North: Studies in the Dutch and Flemish Baroque Influence on French Rococo Painting* (New York, 1977); see also Colin B. Bailey, "Surveying Genre in Eighteenth-Century French Painting," in *The Age of Watteau, Chardin and Fragonard: Masterpieces of French Genre Painting*, exh. cat. (Ottawa, National Gallery of Canada, 2003), pp. 18–21; and Donald Posner, *Antoine Watteau* (Ithaca, New York, 1984), pp. 12–40. The contribution of Venetian painting should not be ignored, for which see Michel Hochmann, "Watteau, la fête galante et Venise," in Valenciennes (2004), pp. 57–69.

13 Elise Goodman, "Rubens's *Conversatie à la Mode*: Garden of Leisure, Fashion and Gallantry," *Art Bulletin* 64 (June 1982), p. 258. She covers this material in even greater detail in *Rubens: The Garden of Love as Conversatie à la Mode* (*Oculi: Studies in the Arts of the Low Countries*, vol. 4) (Philadelphia, 1992).

14 On the subject of the importance of the *gravures de mode*, see especially Hélène [de Vallée] Adhémar, "Sources de l'art de Watteau—Claude Simpol," *Prométhée* 3 (April 1939), pp. 67–74; Holmes, *Lancret* (1991), 14–18; and Elise Goodman, "'Les Jeux innocents': French Rococo Birding and Fishing Scenes," *Simiolus* 23 (1995), pp. 251–67. See also the excellent discussion in Cohen, *Art, Dance and the Body* (2000), pp. 141–51.

15 Bernard Picart, Claude Simpol, Claude Duflos (1665–1727), the Bonnart family (especially Robert, 1652–1729, Henri, 1642–1711, and Nicolas I, 1636–1718), the Mariettes (especially Jean 1660–1741 and Pierre II 1634–1716), André Trouvain (1656–1708), and many more.

16 See Mussia Eisenstadt, *Watteau's Fêtes Galantes und Ihre Ursprünge* (Berlin, 1930); François Moureau, "La fête galante ou les retraites libertines," in Valenciennes (2004), pp. 69–71; Thomas Crow, *Painters and Public Life in Eighteenth-Century Paris* (New Haven and London, 1985), pp. 53–56; and Posner, *Watteau* (1984), p. 151.

17 Antoine Furetière, *Dictionnaire universel* (Paris, 1690), n.p.

18 Cohen, *Art, Dance and the Body* (2000), p. 209.

19 "It is certainly a fine and pleasant thing to see the King in this beautiful wilderness [Versailles], on those occasions when he gives either the small fête galantes or those that astonish by their magnificence," *Promenade de Versailles* (Paris, 1669), p. 67. The author wishes to thank Dr. Alison West for her help with Mademoiselle de Scudéry.

20 There are many sources for this subject, among the most useful being François Moureau, "The Games of Thalia and Momus or the Scenes of the Painter," in Margaret Morgan Grasselli and Pierre Rosenberg, *Watteau 1684–1721*, exh. cat. (Washington, D.C., National Gallery of Art, 1984), pp. 475–93, and Crow, *Painters and Public Life* (1985), pp. 48–55.

21 See Crow, *Painters and Public Life* (1985), pp. 53–54.

22 Posner, *Watteau* (1984), p. 116.

23 Donald Posner, "Watteau 'Parklandscapist,'" in *Antoine Watteau (1684–1721): Le peintre, son temps et sa légende* (Paris and Geneva, 1987), p. 114. Nor was the term meant to imply anything negative but was rather a neutral description of the subject, based on its previous use to describe actual gatherings and parties.

24 *Procès-Verbaux*, or Minutes, of the Royal Academy, Fourth Register, July 30, 1712. For easy reference to these minutes, see Anatole de Montaiglon, *Procès-Verbaux de l'Académie royale de peinture et de sculpture, 1648–1793*, 10 vols. (Paris, 1875–92).

25 This hierarchy reflects the understanding among academicians and critics at the time that art which required invention and imagination was superior to that which required only imitation. This hierarchy was codified by André Félibien in his preface to the *Conférence* of 1667. It would be reiterated throughout the eighteenth century, for example, in Antoine Joseph Dezallier d'Argenville's *Abrégé de la vie des plus fameux peintres*, where he notes that "History . . . is the most noble object of painting and . . . requires the greatest knowledge" (Paris, 1745–52), vol I, p. ix: "L'histoire . . . est le plus noble object de la peinture et . . . celui qui demande le plus de connoissances."

26 *Procès-Verbaux*, August 28, 1717. Christian Michel has recently discovered a reference in the archives of the Académie Royale kept at the Bibliotheque de l'École des Beaux-Arts, to Watteau as a "peintre d'histoire." See Marc Fumaroli, "Une amité paradoxale: Antoine Watteau et le comte de Caylus (1712–1719)," *Revue de l'Art* 114 (1996), p. 46, n. 25. See also Fumaroli's discussion, p. 37. As Colin Bailey points out, however, "While Watteau's *Pilgrimage from the Island of Cythera*, 1717, might have been conceived of and even accepted as a history painting, the *fête galante* itself was palpably genre, and thus unclassified within the Academy's existing categories (hence the decision to let Watteau present a "subject of his choosing"), *The Age of Watteau, Chardin and Fragonard* (2003), p. 12.

27 Martin Eidelberg, in Valenciennes (2004), pp. 20–21, notes that French writers of the first half of the eighteenth century—especially the writers of sales catalogues—did not use the term *fête galante* in describing the theme of works of art, preferring the term *sujet galant*, among others.

28 See Posner, *Watteau* (1984), p. 121, for a discussion of Watteau's patrons and collectors.

29 This role is much like the one Alan Wintermute assigns to François Lemoyne, Lancret's close friend and contemporary at the Academy: "It was Lemoyne who created a new type of history painting that might be termed 'gallant mythology,'" Alan Wintermute, *Watteau and His World: French Drawing from 1700–1750*, exh. cat. (New York,

The Frick Collection, and Ottawa, National Gallery of Canada, 2000), p. 218. Wintermute notes Lemoyne's seductive *Hercules and Omphale*, now in the Musée du Louvre, Paris, as having been particularly influential in this development.

30 Colin Bailey, in *The Age of Watteau, Chardin and Fragonard* (2003), p. 9, has ably summed up the situation: "In practice, the Academy's hierarchy presented itself as a duality between history painting and the remaining genres: the acknowledged primacy and superiority of the former did not result in the discredit or discouragement of the latter during the Ancien Régime. Acceptance of the hierarchy (and coexistence within it) was the normal state of affairs. How could it be otherwise, given that until the Revolution all artists of any ambition were trained at the Academy, or sought to gain admission to it in order to exhibit at the biennial Salon. Initially, at least, students were provided with the skills required of the history painter."

31 "No, Lancret is not a poet, but a maker of elegant prose," Charles Blanc, *Les peintres des fêtes galantes. Watteau—Lancret—Pater—Boucher* (Paris, 1854), n.p.

32 This terminology is discussed fully in Bailey, *The Age of Watteau, Chardin and Fragonard* (2003), pp. 3–5.

33 The eighteenth-century appreciation of this aspect of Lancret's art is borne delightful witness by a Salon viewer in 1739, in his comments on Lancret's *Morning* (now in London, National Gallery): "This young person (with her bodice nonchalantly open and her dressing gown thrown back, allowing a glimpse of the objects that inspire guilty thoughts, for me a little like Tartuffe) pours tea into a cup that M. l'Abbé holds out to her with a distracted air; because he is attentive only to this beauty's disarray. A maid takes it all in, smiling slyly," Chevalier de Neufville de Brunabois Montador, *Description raisonnée des tableaux exposés au Louvre, 1739, Lettre à Mme la Marquise de S.P.R.*, Bibliothèque Nationale, Collection Deloynes, pp. 9–10: "Cette jeune personne (dont la chemis négligemment ouverte, et le peignoir détourné dans grand inquietude, laisse voir des objets dont les âmes blesses sont naître dans le Coeur de coupables pensées, pour m'exprimer à un peu comme Tartuffe) verse du Thé dans une tasse que M. l'Abbé lui présente d'un air distrait; parce qu'il n'est attentive qu'au désordre de cette beauté. Une Soubrette qui examine tout cela, en sourit finement."

34 *The Age of Watteau, Chardin and Fragonard* (2003), p. 22.

35 Our main source for information about Lancret's life is the 1743 biography by his friend and lawyer Silvain Ballot de Sovot, *Éloge de M. Lancret, peintre du roi*, J. J. de Guiffrey, ed. (Paris, n.d., ca. 1875). Portions of this biography are reprinted in Georges Wildenstein, *Lancret* (Paris, 1924). Further information about Lancret's life, especially his youth and early training, comes from A. Jal, *Dictionnaire critique de biographie et d'histoire* (Paris, 1872), p. 734. Another important eighteenth-century biography is by Antoine Joseph Dezallier d'Argenville in his *Abrégé de la vie des plus fameux peintres*, 3 vols. (Paris, 1745–52), vol. 3, pp. 289–93. See also the new and corrected edition of 1762, 4 vols., vol. 4, pp. 435f. Pierre-Jean Mariette provides a largely uncomplimentary paragraph on Lancret in his *Abecedario et autres notes inédites de cet amateur sur les arts et les artistes*, published by Philippe de Chennevières and Anatole de Monaiglon, *Archives de l'art français* (Paris, 1851–60, 6 vols.), vol. 3, pp. 55–56.

The frequent references to Lancret in the minutes or *Procès-Verbaux* of the Academy can be found in Montaiglon, *Procès-Verbaux*, vol. 4; the announcement and descriptions of exhibited works and the publication of engravings after Lancret's work were frequently published in the *Mercure de France*. Those announcements have been reprinted

in Wildenstein, *Lancret* (1924), pp. 44–67, in the "Tableau Chronologique."

36 Ballot, *Éloge* (1743), p. 16.

37 Wildenstein, *Lancret* (1924), p. 10.

38 Montaiglon, *Procès-Verbaux*, vol. 4, p. 69. See also Wildenstein, *Lancret* (1924), pp. 44–45, for the early dates of participation in the Academy.

39 Ballot, *Éloge* (1743), p. 17, and Dezallier d'Argenville, *Abregé* (1745 ed.), vol. 3, p. 289.

40 For more on this taste, see Bailey, *The Age of Watteau, Chardin and Fragonard* (Ottawa, National Gallery of Canada, 2003), pp. 18–21; Posner, *Watteau* (1984), pp. 12–15; and Emma Snoep-Reitsma, "Chardin and the Bourgeois Ideals of His Time," *Nederlands Kunsthistorisch Jaarboek* 24 (1973), pp. 148–51 and 158–62.

41 Montaiglon, *Procès-Verbaux*, vol. 4, p. 280. The reception piece was engraved in 1743 by J. P. Le Bas as his reception piece to the Academy, and the appearance corresponds to the Wallace Collection painting, although the dimensions do not match those given in the *Mercure de France*. They might have made a mistake as to size. For more on this painting, see John Ingamells, *The Wallace Collection Catalogue of Pictures III: French before 1815* (London, 1989), pp. 228–30.

42 "Bien dans le genre de Watteau," Ballot, *Éloge* (1743), p. 21.

43 "Les vrais connoisseurs ne s'y méprennent pas," Ballot, *Éloge* (1743), p. 21.

44 The painting in London, Wallace Collection, *Fête in a Wood*, is probably the 1722 entry, *Fête dans un bois*; see Margaret Morgan Grasselli, "Eleven New Drawings by Nicolas Lancret," *Master Drawings* (Autumn 1986), pp. 23–24, no. 381; and Ingamells, *The Wallace Collection* (1989), pp. 232–33. The 1723 entry was *The Lit de Justice at the Majority of Louis XV*, now in Paris, Musée du Louvre, for which, see

Holmes, *Nicolas Lancret* (1991), pp. 56–57.

45 According to Ballot, *Éloge* (1743), p. 19, Lancret exhibited two paintings at the Exposition de la Jeunesse that some people mistook for paintings by Watteau. This mis-understanding angered Watteau, and it was the end of the relationship between the two artists. According to Ballot, the two remained on this footing until Watteau died.

46 For listings of the works on view at the Exposition de la Jeunesse as they were described in the *Mercure de France*, see E. Bellier de la Chavignerie, "Notes pour servir à l'histoire de l'Exposition de la Jeunesse," *Revue universelle des arts XIX* (1864), pp. 38–67. For a useful discussion of the Exposition and its importance and exhibition opportunities for painters at the time, see Philip Conisbee, *Painting in Eighteenth-Century France* (Ithaca, New York, 1981), pp. 22–23; and Crow, *Painters and Public Life* (1985), pp. 82–88.

47 Bellier de la Chavignerie, "Notes," (1864), p. 16.

48 Bellier de la Chavignerie, "Notes," (1864), p. 16; and the *Mercure de France* (June 1722), p. 88.

49 For more on this Salon, see Georges Wildenstein, *Comte Rendu par le Mercure de France du Salon de 1725* (Paris, 1924). For more discussion of the participants and their contributions, see Jean-Luc Bordeaux, "The Rococo Age," in *The Rococo Age* (1983), p. 15–16.

50 Wildenstein, *Comte Rendu* (1924), pp. 46–47.

51 For an illustration of *Pleasures of the Bath*, see Mary Tavener Holmes, "Deux Chefs-d'Oeuvres de Nicolas Lancret, 1690–1743," *Revue de Louvre* 1 (1991), pp. 40–42; for the *Luncheon in the Forest*, see Wildenstein, *Lancret* (1924), fig. 110.

52 Sotheby's, New York, *Important Old Master Paintings*, May 22, 1992, lot 76.

53 Louis-Antoine de Pardaillan de Gondrin,

duc d'Antin (1665–1736), headed the department from 1708 to 1736. The duc ordered a painting, *The Accident at Montereau*, a presumably humorous depiction of a comical accident that befell Marie Leczinska on her way to Fontainebleau to marry Louis XV. The painting remains lost, but Lancret was paid for it in 1727, so it must have been delivered. For this commission, see Paul Mantz, "Copie sur l'original envoyé par M. le duc d'Antin au Sr. Lancret," *Archives de l'art français* I (1851–52), pp. 301–3; and Anthony Valbrègue, "Nicolas Lancret: Un Tableau commandé par le duc d'Antin," *Nouvelles Archives de l'Art français* 3e série, 8 (1892), pp. 271–72.

54 Lancret's decorations for the first-floor cabinet of the house of Abraham Peyrenc de Moras (a house at 23, Place Vendôme, designed for Peyrenc by Jacques V. Gabriel in 1723–24) remained in situ throughout the nineteenth century, and photographs of the installation still exist [see FIGURE 75]. See Rochelle Ziskin, *The Place Vendôme: Architecture and Social Mobility in Eighteenth-Century Paris* (Cambridge, United Kingdom, 1999), pp. 109–13; Bruno Pons, *De Paris à Versailles* (Strasbourg, 1983), pp. 122–26 and pp. 218–19; and Anne Thiry, "L'Hôtel Peirenc de Moras, puis de Boullongne," *Bulletin de la Société de l'histoire de Paris et de l'Île de France* 106 (1979), pp. 62–66. Several of the long canvases are in Paris, Musée des Arts Decoratifs. For the *Four Seasons* for Leriget de la Faye, see Holmes, *Lancret* (1991), pp. 70–71.

55 The announcement that prints after the La Faye paintings were to appear was made in the *Mercure de France*, June 1730, p. 1,184. Each of the four paintings was engraved by a different artist: *Autumn* by N. Tardieu; *Spring* by B. Audran; *Summer* by G. Scotin; and *Winter* by J.-P. Le Bas.

56 The versions are in London, Wallace Collection (in a blue dress); Nantes, Musée des Beaux Arts (in a blue dress); and Leningrad, State Hermitage Museum (in a yellow dress). The example in the Wallace Collection most closely resembles the engraving made after the painting and must certainly be the first one, the one owned by Leriget de la Faye, who probably provided the verses to the engraving. For the Wallace Collection painting, see Ingamells, *The Wallace Collection* (1989), pp. 220–23; for Nantes, see Emile Dacier, "À propos du portrait de la Camargo, par Lancret, au Musée de Nantes," *Les Musées de France* 3 (1911), pp. 42–45; for the Hermitage work, see Inna Nemilova, *The Hermitage Catalogue of Western European Painting: French Painting, Eighteenth Century* (Moscow and Florence, 1986), pp. 163–64. Lancret also used the figure of Mademoiselle Camargo in an elaborate *fête galante*, where she is paired with a male dancer. That painting is in Washington, D.C., in the National Gallery of Art [FIGURE 68]. For more on that version, see Holmes, *Lancret* (1991), pp. 67–69.

57 The publication of Laurent Cars's engraving, done after the painting in the Wallace Collection, was announced in the *Mercure de France*, July 1731. Documents concerning the suit of June 25, 1731, and the award in favor of Lancret of March 17, 1732, can be found in Wildenstein, *Lancret* (1924), pp. 50–52.

58 The painting has reemerged after being lost for a very long time and is now in Rheinsburg Palace. See Christoph Martin Vogtherr, *Nicolas Lancret: Porträt der Tänzerin Maria Sallé* (Berlin and Potsdam, 2001).

59 The Grandval portrait of 1742 is in the Indianapolis Museum of Art; see Holmes, *Lancret* (1991), pp. 94–95. Lancret's scene from the *Comte d'Essex* by Thomas Corneille is in the Hermitage, see Nemilova, *The Hermitage Catalogue* (1986), pp. 165–66. Two other scenes from the theater are known from the engravings made after them, see Wildenstein, *Lancret* (1924), figs. 65 and 66.

60 For more detail on these collectors and the exact works by Lancret that they owned, see Holmes, *Lancret* (1991), p. 151, n. 75.

61 See, for these, Holmes, *Lancret* (1991), pp. 151–52, n. 76.

62 For Lancret's contributions, see Mary Tavener Holmes, "Lancret, décorateur des petits cabinets de Louis XV à Versailles," *L'Oeil* 356 (1985), pp. 24–31. For the decoration of the rooms as a whole, see Xavier Salmon, *Versailles: Les chasses exotiques de Louis XV*, exh. cat. (Paris, 1995).

63 For the *Suite*, see A. Hédé-Hauy, *Les Illustrations des Contes de la Fontaine* (Paris, 1893); Florence Ingersoll-Smouse, *Pater* (Paris, 1928), pp. 74f.

64 "Dessiner, ou peindre, étoit tout ce qui pouvoit occuper M. Lancret. Il avoit si fort l'amour du travail que les jours de solemnité lui auroient été à charge, s'il n'avoit eu à les remplir des devoirs de la religion, ainsi qu'ila toujours fait jusqu'au dernier moment de sa vie," Ballot, *Éloge* (1743), p. 25.

65 "Son humeur polie, douce, liante et affable," Edme-François Gersaint, *Catalogue raisonné des diverses curiosités du cabinet de feu M. Quentin de Lorangère* (Paris, 1744), p. 192.

66 "C'étoit un homme assez sérieux, et qui, peu répandu dans le monde, ne s'occupoit que de son travail," but who remained "seulement un practicien," Pierre-Jean Mariette, *Abecedario* (1851–60), vol. 3, p. 55.

67 "L'histoire d'une vie laborieuse, telle qu'a été celle de M. Lancret, est, pour ainsi dire, tout renfermée dans cette quantité d'ouvrages qui nous restent de lui," Ballot, *Éloge* (1743), p. 21.

68 The collection includes Italian, Netherlandish, and French paintings and a large number of prints from the same three schools. The catalogue is reproduced in Émmanuel Bocher, *Les Gravures françaises du XVIIIe siècle: "Lancret"* (Paris, 1875–77), pp. 103–17; the collection is discussed by Marianne Roland Michel, "Observations on Madame Lancret's Sale," *Burlington Magazine* III (October 1969), supplement i–vi.

69 A notation which Roland Michel plausibly ascribes to Lancret rather than Rémy, the expert for the sale.

70 For more on that painting, see Christoph Martin Vogtherr et al., *Nicolas Lancret: Der Guckkastenmann* (Berlin and Potsdam, 2003); and Holmes, *Lancret* (1991), pp. 104–105.

71 François Moureau, "Watteau in His Time," in Grasselli and Rosenberg, *Watteau* (1984), p. 472.

72 There is a vast amount of literature on the last years of the reign of Louis XIV. Two good sources with which to begin one's study are the *Memoires of the duc de Saint-Simon* (especially the sorry story of the year 1709) and Nancy Mitford's biography of Louis XIV, *The Sun King* (New York, 1966). It is perhaps not the most reliable history, but it is great fun to read and makes a fine introduction. The creation of the central monument of that period, the palace of Versailles, is described wonderfully by Guy Walton in *Louis XV's Versailles* (Chicago, 1986).

73 Katie Scott, *The Rococo Interior: Decoration and Social Spaces in Early Eighteenth-Century Paris* (New Haven and London, 1995), p. 147.

74 Ibid., p. 147.

75 Ibid., p. 213.

76 Ibid., p. 213.

77 Thomas Crow, *Painters and Public Life* (1985).

78 Ibid., p. 40.

79 Anne L. Schroder, "Genre Prints in Eighteenth-Century France: Production, Market and Audience," in *Intimate Encounters: Love and Domesticity in Eighteenth-Century France*, exh. cat. (Hanover, N.H., Hood Museum of Art, 1997), p. 70.

80 There is ample evidence in Lancret's life and art to support the claim that he was astute at self-promotion and well aware that all avenues for success needed to be explored. For example, very early in his career, Lancret courted the patronage of both the Crown

and the emerging financial elite. He painted four sketches, evidently on speculation, as they remained in his collection; two of them are scenes from the life of Louis XV, and two from the life of Pierre Crozat. All four depict scenes from the life of someone of great potential value to him as a patron. Also, he initiated professional printmaking after his work at a very early stage and kept it up throughout his career; the prints after his work sold very well and spread his popularity.

81 "Fountains are, after plants, the main ornament of gardens. One places them at the most beautiful spots, and where they can be seen from all sides," Antoine-Joseph Dezallier d'Argenville, *La Théorie et le pratique du jardinage* (Paris, 1709), chap. 9, n.p.

82 Deborah Marrow, *The Art Patronage of Maria de'Medici* (Ann Arbor, 1982), p. 23, notes that the grotto was modeled on Buontalenti's grotto for the Boboli Gardens and relates to Maria's desire to have the Luxembourg Palace resemble the Pitti Palace in Florence.

83 See L.-A. Hustin, "La Création du Jardin du Luxembourg," *Archives de l'Art français* 8 (1914), pp. 90–98. He discusses the date of the grotto on p.92. See also Marie-Noëlle Baudouin-Matuszek, *Marie de Medicis et le Palais de Luxembourg* (Paris, 1991), pp. 236–38; and Gustave Hirchfeld, *Le Palais de Luxembourg* (Paris, 1931), pp. 123–27.

84 By whom no one is certain; see Hustin, "La Création," p. 93.

85 My thanks to Alan Salz and Bradley Whitehurst for including a swing by the fountain to check on the marine maiden in their morning jog.

86 Mark Leonard, Conservator of Paintings at the J. Paul Getty Museum, Los Angeles, cleaned the painting, and Tiarna Doherty, Assistant Conservator, and Yvonne Szafran, Associate Conservator, photographed the images that revealed the changes made by Lancret.

87 For more on Audran, see Grasselli and Rosenberg, *Watteau* (1984), p. 32. For the collaboration of Lancret and Audran, see Anne Thiry, "L'Hôtel Peyrenc de Moras," (1979), pp. 51–84; Pons, *De Paris à Versailles* (1983), pp. 126 and 219; and Ziskin, *The Place Vendôme* (1999), pp. 110–13.

88 "Ce fut encore là qu'il dessinoit sans cesse les arbres de ce beau jardin, qui brût et moins peingné, que ceux des autres maisons roïales, lui fournissoit des points de vue infinis, et que les seuls païsagistes trouvent avec tant de variété dans le même lieu, tantôt par la reunion de plusieurs parties éloignées, tantôt enfin par les differences que le soleil du soir ou du matin apporte dans les mêmes places et sur les mêmes terrains," Anne-Claude-Philippe de Tubières de Grimouard de Pestels de Levis, Comte de Caylus (1692–1765), "Vie d'Antoine Watteau," February 3, 1748, reprinted in Pierre Champion, *Notes Critiques sur les vies anciennes d'Antoine Watteau* (Paris, 1921), pp. 83–84.

89 Kimberly Rorschach, "French Art and the Eighteenth-Century Garden," in *Claude to Corot: The Development of Landscape Painting in France*, exh. cat. (New York, Colnaghi, 1990), p. 112.

90 "Il [Watteau] lui conseiller d'aller dessiner aux environs de Paris quelques vües de paysages," Ballot, *Éloge* (1743), p. 18.

91 As Donald Posner has pointed out, we have underestimated the novelty of the naturalism of these park landscapes and their impact as landscape paintings. See Posner, "Watteau 'Parklandscapist,'" (1987), pp. 113–14.

92 For the *Menuet*, see Jan Lauts, *Karlsruhe Staatliche Kunsthalle: Katalog Alte Meister bis 1800* (Karlsruhe, 1966), p. 166.

93 For a detailed account of the sculpture, its commission, and its setting, see Thomas Hedin, *The Sculpture of Gaspard and Balthazard Marsy: Art and Patronage in the Early Reign of Louis XIV* (Columbia, Missouri, 1983), pp. 42–52 and 133–39.

94 André Félibien, in his *Déscription de la Grotte de Versailles* (Paris, 1679), included twenty engraved plates and a full description of the grotto and the sculpted ensemble.

95 For the Grotto and Félibien's publication, see Susan Taylor-Leduc, "A New Treatise in Seventeenth-Century Garden History: André Félibien's 'Description de la Grotte à Versailles'," *Studies in the History of Gardens and Designed Landscapes: Seventeenth-Century French Garden History* 18 (January–March 1998), pp. 35ff.

96 "Le sculpteur a donné au modèle de cette figure, grand comme le marbre; et le peintre, pour lui marquer sa reconnaissance et combine il estime son présent, lui a envoyé ce tableau. Il a peint la statue qu'il a rendue avec precision et l'a placée dans un bosquet moins orné par les beautés de l'art que charmant par les graces de la nature et situé sous un ciel doux et serein." Coustou describes the painting, then goes on. "La distribution des lumières, l'air vif et léger des Françoises oppose à l'air du Persan, la vérité et la variété des étoffes, le tour spirituel des figures et la légérité de la touché rendent ce tableau piquant pour tous les curieux en general; mais il doit être plus piquant pour vous qui cherchez les compositions raisonnées."

97 Martin P. Eidelberg, "Watteau, Lancret, and the Fountains of Oppenort," *Burlington Magazine* 110 (August 1968), pp. 447–56.

98 For more on this artist, see Marianne Roland Michel, *Lajoüe et l'Art Rocaille* (Paris, 1984).

99 Quoted by Fiske Kimball, *The Creation of the Rococo* (New York, 1943), p. 170.

100 Alan Wintermute, in *Claude to Corot* (1990), p. 132.

101 Ibid., pp. 131–36.

102 "My comrade, when I dance my cotillon, it goes well?" quoted by Jean-Michel Guilcher, *La Contredanse et les Renouvellements de la Danse Française* (Paris, 1969), p. 75, as the refrain (as well as the source of the name of the dance) to *Le Cotillon, danse à Quatre*, published by Raoul-Auger Feuillet, *Quatrième Recueil de Danses à Bal pour l'année 1706* (Paris, 1705).

103 Feuillet, in the preface to his *Quatrième Recueil de Danses à bal pour l'année 1706* (Paris, 1705), p. 126, describes the cotillon as a very old dance, very popular at the time of his writing, and easy to learn: "le cotillon, quoi que Danse ancienne, est aujourd'hui si à la mode à la Cour, . . . c'est une manière de branle à quatre que toutes sortes de personnes peuvent danser sans même avoir appris." Indeed, one dance historian describes it as "sans art." The popularity of the cotillon and the *contredanse* owed much to the fact that they were easily learned and emphasized social interaction over display and pose. The cotillon is very similar to the *contredanse*, and perhaps even a form of the *contredanse*, a very popular style of dance in France from the end of the seventeenth century and throughout the eighteenth. The origins of the *contredanse* and its relationship to the cotillon are outside the scope of this volume, but discussed at length by Cohen, *Art, Dance and the Body* (2000) and Guilcher, *La contredanse et les Renouvellements de la Danse Française* (1969).

104 Cohen, *Art, Dance and the Body* (2000), p. 204.

105 Ibid., p. 127.

106 "On ne connut point d'autre dissipation à M. Lancret," Ballot, *Éloge* (1743), p. 26.

107 The two frontispieces had been known only through engravings (see Wildenstein, *Lancret* [1924] nos. 711 and 712), but one is now in a private collection; both are for harpsichord compositions by Jean-François Dandrieu, organist of the King's chapel, and one is dated 1734. For the opera scenes, see Wildenstein, *Lancret* (1924), nos. 269 and 763. Both were in French private collections at the time of Wildenstein's writing, and their present whereabouts are unknown. The author has not seen them.

108 Meredith Ellis Little and Carol G. Marsh, *La Danse Noble: An Inventory of Dances and Sources* (Williamstown, Massachusetts, 1992).

109 Probably there was more than one. It is very likely that other foursome dances included this step. A survey of the publications of Feuillet from 1703 to 1720, however, turned up no other windmill step. This is the only published example I could find.

110 "Les quatres danseurs forment un moulinet en joignant les mains droites (tour en sense de la montre) puis les mains gauches (tour en sens inverse)."

111 From the poem "Among School Children" by William Butler Yeats. Used with permission.

112 There is a vast amount of literature on the interesting lives of these two women. To explore that bibliography further, see Holmes, *Lancret* (1991), pp. 67–68; and Vogtherr, *Maria Sallé* (2001).

113 Émile Dacier, *Une Danseuse de l'Opéra sous Louis XV: Mademoiselle Sallé (1707–1756)* (Paris, 1909), p. 81.

114 Mademoiselle Sallé was a nymph of Diana in the 1728 opera *Orion*. The set had a temple of Diana; the cast also included Mademoiselle Camargo.

115 "La pruderie de votre nymphe y étant exprimée par le temple de Diane," *The Complete Works of Voltaire* (Geneva, 1969), letter to Thièriot, May 26, 1732.

116 "Ah, Camargo, que vous êtes brillante Mais que Sallé, grands dieux, est ravissante! Que vos pas sont legers et que les siens son doux! Elle ist inimitable et vous êtes nouvelle. Les Nymphs sautent comme vous, Mais les Graces dansent comme elle," *Mercure de France*, January 1732.

117 This radical aspect of eighteenth-century genre painting is discussed by Martin Scheider in his essay "'Sorti de son genre': Genre Painting and Boundary Crossing at the End of the Ancien Régime," in *The Age of Watteau, Chardin and Fragonard* (2003), pp. 60–77. Though his essay focuses largely on the period of 1740–80, what he describes is of much interest for the study of Lancret. For example, he notes on p. 69 that Chardin "subtly pushed the boundaries between the genre category and that of portraiture," much as Lancret does, and, on p. 76, that between 1740 and 1780 an interesting phenomenon was occurring: "Playing a key role in this process of emancipation was the process of interaction, even osmosis, between genre painting, history painting, portraiture, and last but not least, landscape." The work of Lancret tells us that this emancipation was taking place at least two decades earlier.

118 A contemporary copy of the *Quadrille* in Germany has been found and at the time of this writing was in Würzburg with Albrecht Neumaster. This copy, which must date from shortly after the original was made and most probably by a French painter, is bigger on both sides (by about 15 centimeters altogether), but especially on the left. On the left side, one can see another figure down the hill and slightly more landscape; on the right, there is more room to the right of the statue and more foliage. The fact that the original and the copy have both ended up in Germany makes one wonder if the copyist was German, perhaps even working for Frederick II (who had copies made of Lancret and Watteau), but the copy must have been made when the original was still in France, before the original composition by Lancret was cut down to pair with the *Dance in a Pavilion*. Mrs. Mechthild Most, painting conservator at Schloss Charlottenburg, in conversation with the author June 20, 2000, noted that the *Quadrille* was cut down on the left side, which allowed its frame to be the same size as that of the *Dance* [FIGURE 1]. Those two paintings had been put together by the time they were in the collection of the prince de Carignan. They were bought from his estate in 1744 by the comte de Rothenburg for Frederick II.

119 The Poussin is a painting commissioned by the Cardinal Richelieu in 1641, for the ceiling of the Grand Cabinet du Palais Cardinal, and is another example of Lancret using "real" art in his paintings.

120 Such a commission would be for the *Quadrille* only, since the two paintings (the *Quadrille* and the *Dance*) were not planned as pendants by Lancret himself. The *Quadrille* was larger than the *Dance* when it was originally made. See note 118.

121 "Un assez grand Tableau cintré ou l'on voit une danse dans un paysage avec tout ce que l'habilité au peintre a pu produire de brillant, de neuf, et de galante dans le genre pastorale," *Mercure de France* 1724, Bellier de la Chavignerie, "Notes," (1864), p. 16.

122 "Il y a bien vingt-quatre ans qu'il débuta par deux tableaux; un Bal et une Danse dans un boccage [sic], deux Tableaux qui ont été à M. de Julienne [sic] et ensuite à M. le prince de Carignan, et je me souviens qu'ayant été exposés à la place Dauphine un jour de la Feste(sic)-Dieu, ils lui attirèrent de grands éloges," *Abecedario* (1851–53), vol. 3, p. 55. The Jullienne sale of 1767 lists no such Lancret paintings, but they would have long since gone to the prince and thence to Germany. The Carignan sale of 1743 lists these two paintings as "Deux Tableau sur toile...l'un représentant un Bal, et l'autre une Danse, par Nancré," *Catalogue des Tableaux du Cabinet de Feu S.A.S. Monseigneur le Prince de Carignan, Premier Prince du Sang de Sardaigne* (Paris, 1743), lot 64.

123 In his edition of Ballot, *Éloge*, p. 29.

124 "Je vous ai acheté deux tableaux admirables de Lancret, qui sont des sujets charmantes et très-gais; ce sont les deux chef-d'oeuvres de ce peintre; je les ai de la succession de feu M. le Prince de Carignan, qui les a payés à ce peintre, dans ce temps qu'il était encore en vie 10,000 livres, et je les ai eus pour 3000 livres...Il est très difficile de trouver des tableaux de ces deux maitres [i.e., Lancret and Watteau]," reproduced in "Correspondence de Frédéric le Grand, relativement aux arts," *Revue universelle des arts* 5 (1857), pp. 174–75.

125 Christoph Martin Vogtherr and Ulrike Eichner, "Von Potsdam nach Charlottenburg: Annäherung an einen verlorenen Raum," *Museums Journal* 3 (July 2000), pp. 83–85. The documented presence of these paintings in Germany by 1744 destroys the argument once made, by this author and others, that the paintings remained in France during that time and were part of a 1753 sale to Frederick, see Holmes, *Lancret* (1991), pp. 38–39.

126 Dr. Vogtherr has pointed out to the author (in conversation, July 20, 2004) that the existing documentation does not describe which frame was for which painting. He agrees, however, that the logical matching would be the frame with the grape and garden imagery for the *Quadrille* and the frame with the musical imagery for the *Dance*.

127 Putting in place this piece of the puzzle was the work of many hands, and I would like to credit the following scholars and conservators for their work on these discoveries: Mark Leonard, Conservator of Paintings at the J. Paul Getty Museum, for that extra digit; Julia Armstrong-Totten of the Getty Provenance Index, for tracking down the significance of the red number and for establishing the provenance between the twelfth Earl of Pembroke and the Rothschild family (from whom, eventually, the J. Paul Getty Museum acquired it); Catherine V. Phillips, for serving as the author's liaison to the State Hermitage Museum, for translation, for tireless searching of archives in Russia and England, and for moral support; Anastasia Mikliaeva, Office of the Director, the State Hermitage Museum, for assisting in the acquisition of a crucial photograph from the Hermitage Archives; and Ekaterina Deriabina, Curator of European Paintings, the State Hermitage Museum, for assisting

in the discovery of the unpublished Archive page with the painting listed on it, helping the author to see that page in the Archives of the museum, and exploring the various possibilities of provenance with the author and Julia Armstrong-Totten.

128 Frants Labensky, *Catalogue of Paintings in the Imperial Gallery of the Hermitage, and in the Tauride and Marble Palaces, compiled on the Order of His Imperial Majesty by Akimov, Gordeyev, and Kozlovsky with the Participation of F.I. Labensky, Keeper of the Hermitage Paintings, in 1797*, Archives of the State Hermitage, f.1, inv. VI-a, no. 87 (from 1797 until the 1940s). Catherine V. Phillips notes, in an e-mail to the author, February 25, 2004, that the handwriting for this entry and its number include it among paintings entered around or soon after 1787.

129 E. Munich, *Catalogue raisonné des tableaux qui se trouvent dans les galleries et cabinet du palais imperial de Saint-Pétersbourg*, vols. 1–2, 1773–83; vol. 3, 1783–85, Archives of the State Hermitage Museum, f. 1, inv. VI-A, no. 85; and E. Munich, *Catalogue des tableaux qui se trouvent dans les galleries et cabinet du palais imperial de Saint-Pétersbourg* (St. Petersburg, 1774). For the 1774 inventory, see "Musée du Palais de l'Ermitage sous Le Regne de Catherine II," *Revue Universelle des Arts* (Tome troisième, 1861).

130 E-mail communication to the author from Julia Armstrong-Totten, July 16, 2002.

131 Apparently, he made a specialty of French art and Dutch art of the seventeenth century. His 1786 catalogue of the thousands of books and prints available at his shop contained a preponderance of French work.

132 The author wishes to thank Catherine V. Phillips for providing painstaking translation of relevant (and lengthy!) passages from Levinson-Lessing's book. All quoted translations are by Catherine V. Phillips. A second edition was published in 1986, with an index.

133 Levinson-Lessing, *History* (second edition, 1986), p. 106.

134 "We must also bear in mind that henceforth all the invoices, including paintings and other works of art purchased from Fonvizin were signed only by Klosterman, who was in charge of the commerce in works belonging to the arts founded by Fonvizin," ibid., p. 356. See also p. 346.

135 Levinson-Lessing, *History* (1986), p. 353, quoting from Klosterman's notes, p. 292: "I often traveled with him to the shops in which, as at auctions, he was able to make some significant purchases. When he himself did not wish to travel to some celebrated sale of works of art he sent me to do his trading, first marking in the catalogue what was to be bought."

136 Ibid., pp. 356–57. Levinson-Lessing gives no reference for knowing that Catherine visited the shop.

137 Ibid., p. 358.

138 Ibid., p. 359.

139 My thanks to Irina Sokolova, Curator of Netherlandish Art, the State Hermitage Museum, for relating this information to Catherine V. Phillips. She cites de Flieger's *Ships in Windy Weather*, Hermitage inventory number 1626 as one example, and says that there are other Dutch seventeenth-century paintings in her care with this notation that Levinson-Lessing does not include. She further notes that not all the works known to have come through Klosterman bear this notation on the back. See also Levinson-Lessing, *History* (1986), p. 359 and n. 50, p. 382.

140 Levinson-Lessing, *History* (1986), n. 20, p. 382.

141 Ibid., p. 377.

142 Mariette, *Abécédario* (1851–60), vol. 3, p. 55: "Il procure en assez peu de temps une fortune honnête." The sale of prints after Lancret's work was very successful and the *Mercure de France* pointed this out repeatedly. On the publication of the *Mademoiselle Sallé*,

the *Mercure* (April 1733, p. 773) notes that it was "highly successful"; the *Four Ages of Man*, the *Mercure* (July 1735, pp. 1,612–14) describes as "selling with great success"; and of *Le Glorieux*, the *Mercure* (March 1741, pp. 567–68) points out that it is "selling well and deserves to."

143 "Il rassemble une riche galerie de tableaux, des pierres gravées, des bronzes, des marbres, des porcelains, et une precieuse biblio- thèque. Ses collections étaient accessibles à tous, aux curieux comme aux hommes d'études," A. Rochas, *Nouvelle Biographie Universelle* (Paris, 1853), vol. 28, n.p.

144 D'Alembert describes La Faye as "un homme du goût" who preferred "le chef d'oeuvre d'un peintre presque inconnu, au mediocre table d'un célèbre Artiste," Jean le Rond d'Alembert, *Histoire des membres de l'Académie française* (Paris, 1787), vol. 4, p. 432.

145 Gaius Asinius Pollio (76 B.C.–A.D. 5), Roman poet, orator, and historian, a con- temporary and supporter of Virgil and founder of the first public library in Rome. The author thanks Peter C. Berry, resident classicist, for this information.

146 "He combined the merits of Horace and Pollion, Now protecting Apollo and now marching in his retinue. He received two gifts from the Gods, the most charming they can bestow: One was the talent to please; the other, the secret of being happy," quoted in d'Alembert, ibid., vol. 4, p. 432.

147 "Lorsque M. Lancret fut porter à M. de la Faye le second tableau, M. de la Faye fut si touché de son progrés qu'il rompit de premier marché fait et lui donna le double du prix don't ils étoient convenus. Un Médicis en eut-il fait davantage?" Ballot, *Éloge* (1743), pp. 19–20; see also Dezallier d'Argenville, *Abregé* (1745 ed.), vol. 3, p. 290.

148 Ballot, *Éloge* (1743), pp. 23–24.

149 The *Mercure de France*'s announcement of the engraving, in July of 1731, described the painting as being in the cabinet of Leriget de la Faye. For more on this subject, see Èmile Dacier, "Les Portraits Gravés de La Camargo au XVIIIe Siècle," *La Revue de l'Art Ancien et Moderne* 30 (1911), pp. 143–48; and Bocher, *Les Gravures* (Paris, 1875–77), cat. 17A.

150 Rochelle Ziskin, e-mail communication with author, January 19, 2003.

151 Nicolas-Charles Le Prevost, *Inventaire de M. Leriget de La Faye*, Ètude de M. Morel d'Arleux, rue des Saint-Pères. It is dated July 11, 1731, and the call number is Minutier Central, Ètude I: 355.

152 Ziskin, e-mail of January 19, 2003.

153 Unfortunately, the Labensky inventory has no notation on the subject of the paint- ing's departure.

154 According to Julia Armstrong-Totten, "In 1840 Nicholas I decided to build a new pic- ture gallery and a committee was formed to review the paintings in the Imperial collec- tion. Around 1,600 paintings were designated for the new museum and the remainder was deemed second rank, primarily because of damage, their subject matter, or simply that Nicholas did not like them. This group was further divided up and in 1854 pictures were either given away (to the suburban palaces, official buildings, churches or to noblemen as gifts) or they were put up for sale. Some sources suggest over 1,200 paintings were sold off, but, according to Ms. Deriabina, there is no evidence that our picture was among them. She claims it does not appear in the catalogue of the sales that took place starting on June 6, 1854," e-mail of May 30, 2002.

The painting is not listed in the inventory of the museum started in 1859, *Inventory of Pictures and Ceiling Paintings Belonging to Department 2 of the Imperial Hermitage*, 1859 Archives of the State Hermitage, f. 1, inv. XI-E, no. 1.

For more on the sales of Nicholas I, see Baron N. Wrangell, "Imperator Nicolas I

and the Arts," *Starye gody* (September 1913), pp. 53–163. Thanks to Nadeja Prokazina for her translation of this article.

155 His diplomatic career in England lasted from 1784–1806, and he is buried in the Pembroke family vault in Marlyebone, London. The street where he lived in St. John's Wood, London, is now called Woronzow Road.

156 According to Julia Armstrong-Totten, e-mail to the author, July 31, 2003, "Anything that belonged to George's wife, she got to keep. If the picture was somehow a gift to her or both of them, then she had some control over it, but it is entirely possible she might have given it to Robert as a gift."

157 Catherine V. Phillips points out that it is strange that Labensky would not note such a gift in his catalogue, as it was entered in his inventory during a period when he was still trying to make note of where the paintings went (e-mail, February 25, 2004). The author wishes to thank her and Steven Hobbs, the archivist of Wiltshire County where the Pembroke family archives are held, for their search of those archives, to no avail.

158 Robert Henry Herbert, Twelfth Earl of Pembroke, his sale, Paris, June 30, 1862, no. 16.

159 Edouard Fould, his sale, Paris, Hôtel Drouot, April 5, 1869, no. 10.

160 According to Julia Armstrong-Totten, this description of M. Rouzé comes from a handwritten annotation in the Getty Research Library copy of the sales catalogue (#3). E-mail to author, May 30, 2002.

161 The Baron Gustav died in 1911. See *Inventory of the Collection of Baron Gustav de Rothschild* (Paris, ca. 1911).

A NOTE ON THE STUDY AND TREATMENT OF NICOLAS LANCRET'S *DANCE BEFORE A FOUNTAIN*

1 For the most recent published technical study of Lancret's painting materials, see Paul Ackroyd, Ashok Roy, and Humphrey Wine, "Nicolas Lancret's *The Four Times of Day*," *National Gallery Technical Bulletin*, 25 (2004), pp. 48–61.

2 In this study, an Inframetrics digital infrared camera with a platinum silicide detector was used. The images were created by compositing multiple video captures in Adobe Photoshop. The work was carried out by Tiarna Doherty, Assistant Conservator, and Yvonne Szafran, Associate Conservator, the J. Paul Getty Museum.

3 See page 55.

4 See page 52.

5 See Gilbert Émile-Mâle, "La première transposition au Louvre en 1750: *La Charité* d'Andrea del Sarto," *Revue du Louvre* 3 (1982), pp. 223–30.

6 For a discussion of the history of the transfer process, some of its technical details, and a bibliography, see C. Hassall, "Transfer," *Grove Art Online* (Oxford University Press), accessed December 16, 2004, http://www.groveart.com.

7 The mortise and tenon joins at the corners and—most notably—at the central cross-bar were constructed with a flared design that is often found in early-nineteenth-century French stretchers.

INDEX

ACKNOWLEDGMENTS

This book was a pleasure to write from start to finish, and many people helped along the way.

As is always the case in my work, my most profound debt is to Donald Posner, my mentor and friend, who suggested the subject of Nicolas Lancret to me some twenty-five years ago, and this painting as the subject of a book as well. Thanks, too, to Alan Salz, who notified me that the painting was coming to America and kept me apprised of its itinerary. I must thank Dawson Carr and Scott Schaefer for letting me know the purchase was complete, and for inviting me to Los Angeles immediately to see the painting. Mark Leonard and I spent several wonderful days in his studio, Mark cleaning and working his magic, and me watching—it was a unique privilege and formed a wonderful chapter in this book.

The research for this book has taken me from California to New York to Paris to Germany to St. Petersburg, and my thanks must range equally far and wide. At the Getty Museum Paintings Department, Scott Schaefer, Curator, and Jon Seydl, Assistant Curator, provided support and a careful reading. Julia Armstrong-Totten of the Getty Provenance Index did crucial research and was a terrific partner in the painstaking work on the provenance. Nadeja Prokazina, a Getty intern when the book was being researched, provided Russian language skills. In Russia, my thanks go to Ekaterina Deriabina, Alexander Kruglov, Ira Sokolova, and Catherine Phillips, who helped us solve the mystery of the painting's eighteenth-century travels.

Perrin Stein, Assistant Curator of Prints and Drawings at the Metropolitan Museum of Art, and Christoph Martin Vogtherr, Curator, Stiftung Preußische Schlösser und Gärten, Berlin-Brandenburg, both read early drafts of the manuscript and made very helpful comments.

Thanks, too, to Peter C. Berry for his support and for a close editorial reading in the final stages that caught several bloopers! Our children, Shirley L. Berry, James R. Berry, and Peter W. Berry, tolerated the trips and the crankiness, and carved out a corner of the den for me.

Various other scholars and friends have lent a hand as well: Becky MacGuire, Nicola Courtright, George Shackelford, Rochelle Ziskin, Sarah R. Cohen, Joseph Baillio, Xavier Salmon, Alan Wintermute, Colin Bailey, Alison West, and Nicolas Hall.

I would also like to thank the Frick Art Reference Library and the New York Public Library for the Performing Arts. The resources and helpful assistance provided by both institutions is well known to all scholars in the history of art, and much appreciated.

In Getty Publications, I am grateful to Mark Greenberg, Editor in Chief, for supporting and encouraging this book into production, to Catherine Lorenz for her sensitive design, and to Suzanne Watson for her efforts as production coordinator. And finally, to my amazing editor, Mollie Holtman, who was a pillar of support, wisdom, and clarity, it has been a joy to work with you, and the book was enriched by your contributions.